D0887547

IMAGES
of America

CHICAGO'S HORSE RACING VENUES

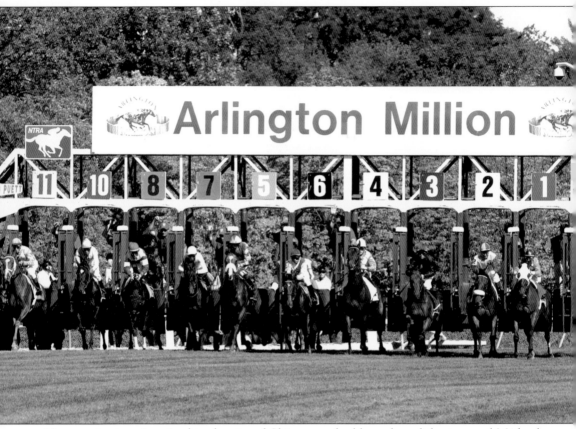

Horse racing is as ingrained in the city of Chicago as the blues, deep-dish pizza, and Michael Jordan. For over 175 years, Thoroughbred and Standardbred racing have survived and thrived through countless scandals, fires, renovations, and closings. This book is an attempt to chronicle some of the top horses and people involved in the Chicago horse racing industry over the years, and to spotlight their efforts and accomplishments. (Author's collection.)

On the cover: The trotter Spec's Boy strides out to win over a pair of rivals at Sportsman's Park on August 7, 1988, for driver-trainer Greg Lance in a career best time of 1:57.4f. The son of Rader Guy—Star Spec—Spectator earned $306,849 in his career for owner Robert Clark of Granite City. (Author's collection.)

IMAGES
of America

CHICAGO'S HORSE RACING VENUES

Kimberly A. Rinker

ARCADIA
PUBLISHING

Published by Arcadia Publishing
Charleston SC, Chicago IL, Portsmouth NH, San Francisco CA

Printed in the United States of America

Library of Congress Control Number: 2008941120

For all general information contact Arcadia Publishing at:
Telephone 843-853-2070
Fax 843-853-0044
E-mail sales@arcadiapublishing.com
For customer service and orders:
Toll-Free 1-888-313-2665

Visit us on the Internet at www.arcadiapublishing.com

*This book is dedicated to my parents, Don and Ginger Rinker,
my best friends and inspiration always.*

CONTENTS

ACKNOWLEDGMENTS

The author thanks the following individuals and organizations for supplying photographs and personal recollections that aided in the preparation of this book: Bill Blessing, Joan Colby, Peter Galassi, Bob Larry, Jim Miller, Mike Paradise, Kathy Parker, Mark Saporito, Ben Wessels, Dave Zenner, and the Worth and Homewood Historical Societies. The author also wishes to express her thanks to the countless trainers, drivers, jockeys, owners, breeders, caretakers, and horses involved in the Chicago Standardbred and Thoroughbred racing industries. These brave souls have nurtured and kept racing alive in the Windy City over the years and are the true unsung heroes of the sport.

INTRODUCTION

Horse racing in Chicago got its start on the city streets and rural byways just as the Windy City was morphing into a metropolitan area in the 1830s. Thoroughfares were sectioned off, and local riders or drivers would sit atop or behind their steeds, and the contests would begin. By 1840, a racing club was established and a small track was built for harness racing, near Indiana Avenue and Twenty-sixth Street in the city. In 1854, the Garden City track opened on the Near South Side, followed a year later by Brighton Park, located six miles southwest of the Loop at Forty-eighth Street, near Western and Kimball Streets.

As Chicago grew and its populace expanded, racetracks for both breeds began to spring up like tulips on a May morning. Curiously, however, throughout the 19th century racetracks opened, closed, and often mysteriously burned to the ground with wicked abandon.

In 1864, the Union Stock Yard Company erected Dexter Park at Forty-second and Halsted Streets, and in 1878, the West Side Driving Park was established next to Chicago's Garfield Park Horse Speedway, which had been built in 1868. Located five miles west of the Loop on a one-square-mile setting, Garfield Park was the site of constant altercations, and during an 1879 raid, a horseman shot two Chicago policemen and the track was closed permanently.

During this same time, Chicago's fair board incorporated and established the Cook County Fairgrounds on North Avenue, between Fifth and First Avenues, adding a half-mile track to the grounds, which later became Maywood Park. Short harness meetings were held there until 1905, and in the early 1930s, nonwagering Standardbred programs were contested under lights, until Maywood opened in 1946, offering pari-mutuel harness racing.

In 1883, Washington Park was built in the Woodlawn community at a cost of $150,000, playing host to the $100,000 American Derby, the second-richest race in the country at the time. In 1891, Edward J. Corrigan established Hawthorne Race Course, located just west of the city limits in Stickney, and Aurora Downs, located 37.5 miles west of Chicago, opened for the first time with a four-day harness meet beginning on July 21, 1891.

Forest Park Thoroughbred Racetrack, also known as the Harlem Jockey Club—located nine miles west of the Loop—was erected in 1894 but was leveled by a 1904 fire. That track stood at Harlem Avenue, near the Des Plaines River and First Avenue, between Cermack (Twenty-second) and Madison Streets, just south of where Maywood Park is located today.

In 1890, the neighborhood of Ravenswood on Chicago's northwest side established a half-mile trotting track in the area bounded at the west by Clark and Kedzie Avenues and by Montrose and Foster Avenues on the north side of the city, but its tenure was short-lived.

When Hempstead Washburne was elected mayor of Chicago in 1892, he began a campaign to shut down the racetracks and was successful in 1905. His ban on gambling in Illinois remained in effect until 1922.

After Tom Carey purchased Hawthorne in 1909 from Corrigan, he tried to reopen the Stickney one-miler twice, but Chicago police stopped him. Carey did, however, succeed in conducting a 13-day Thoroughbred meeting in 1916 at Hawthorne, before the authorities stopped him. When the ban lifted in 1922, the enthusiasm for horse racing erupted like a cloaked volcano. Aurora was the first to reopen in 1923 with a short harness racing meeting.

In 1925, Col. Matt J. Winn of Kentucky came to Illinois, purchased 1,050 acres just south of Crete along Hubbard's Trail (Route 1), and established Lincoln Fields (now Balmoral Park) at a cost of $2 million. Washington Park reopened in a new location on July 3, 1926, in south suburban Homewood, 28 miles south of the Loop, just west of Halsted Street on 175th Street, and the American Derby was reborn.

Arlington Park opened in 1927 for founder California businessman Harry D. "Curly" Brown, and later become Illinois's premier Thoroughbred facility. Later, when its grandstand and clubhouse burned to the ground in 1985, Arlington held its self-dubbed Miracle Million with great success. A total of 35,651 fans attended, sitting on temporary bleachers and in tents, earning the track an Eclipse Award, racing's top honor. After several face-lifts and renovations, Arlington reopened as Arlington Internationals Racecourse on June 28, 1989.

During the 1930s, Hawthorne took over Lincoln Field's racing dates and introduced races restricted to Illinois-bred horses for the first time. Chicago harness horsemen discussed plans to build a half-mile Standardbred track in Lincoln Park in the mid-1930s, just a few blocks north of downtown, but their efforts failed to garner support from city officials.

With the onset of World War II in 1941, Chicago racing was put on hold. Lincoln Fields closed, and its stakes shifted to Hawthorne, followed by Arlington in 1943, after which Thoroughbred racing shifted to Washington Park. Hawthorne, however, flourished during the 1940s—establishing $1,000 minimum purses and featuring races restricted to Illinois-owned horses for the first time. In 1943, Hawthorne scored its first $1 million handle and in 1944 posted daily average handles of $925,328.

Businessman Edward J. Fleming bought Lincoln Fields for $1.2 million in 1947, but the track remained closed until 1951, and their races were contested at Washington Park. A fire on January 20, 1952, damaged Lincoln Fields' grandstand and prevented the plant from opening that year, and all races through 1953 were shifted to Hawthorne. Lincoln Fields finally reopened on May 20, 1954, with Thoroughbred racing, before a crowd of 16,670.

In 1955, Benjamin Lindheimer of Washington and Arlington Parks formed the Balmoral Jockey Club, purchasing Lincoln Fields and renaming it Balmoral Park. When he died on June 5, 1960, his daughter, Marge Everett, established Chicago Thoroughbred Enterprises and ran the three tracks until she sold Balmoral in 1967 to William S. Miller, who converted Balmoral into a half-mile harness track. In 1973, Miller sold it to Edward J. DeBartolo, who in turn sold it to a group headed by George Steinbrenner and the Johnston family later that decade.

Sportsman's Park was the premier Windy City harness racing venue during the 1970s, 1980s, and 1990s, as the nation's finest trotters and pacers graced its oval. The Cicero plant was the number one harness track in the country for summer racing, with its signature American National contests. Hawthorne, seeking to capitalize on Sportsman's success, initiated a winter harness racing meet in the 1970s that continued into the 21st century.

When offtrack betting parlors (OTBs) became legal in Illinois in the mid-1990s, the fan base shifted from the racetracks to the parlors, and attendance and on-track handles began to drop at the Chicago tracks. As a result, purses dwindled while cost-of-living expenses increased, causing both breeds to experience financial hardships over the ensuing years that continue today.

One

THE EARLY YEARS
BEFORE THE 1920S

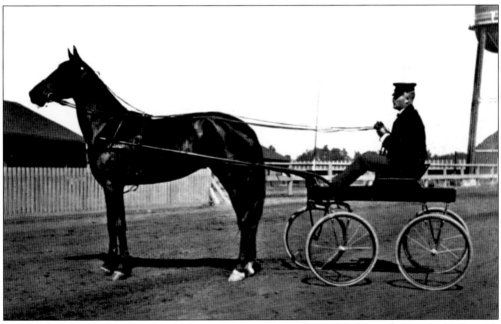

The trotter Sunland Belle is hooked to a four-wheeled sulky at Washington Park in 1901, with trainer-driver F. G. Hartwell holding the lines. Washington Park consisted of 372 acres stretching from Cottage Grove Avenue between Fifty-first and Sixtieth Streets. Opening in 1883 at a cost of $150,000, Washington Park included walking paths, carriage roads, and picnic areas and in the 1920s hosted baseball teams that played on the baseball fields located there. (Photograph by Murray Howe, courtesy of Don Daniels.)

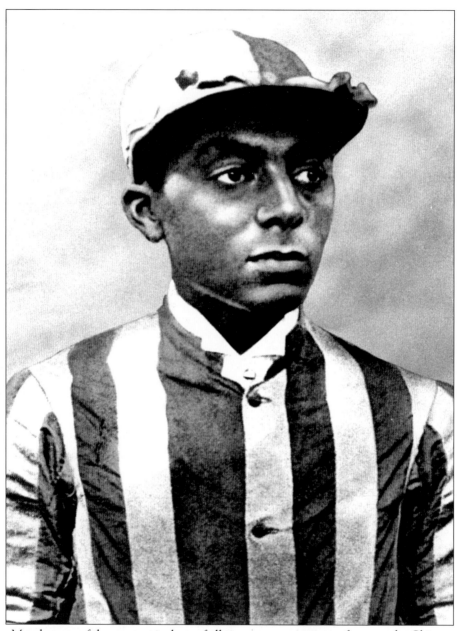

Isaac Murphy, one of the greatest jockeys of all time, was a prominent force on the Chicago and national racing scene in the late 1800s. Murphy was born on April 16, 1861, at David Tanner's Pleasant Green Hill Farm in Frankfort, Kentucky, and became a jockey at age 14, winning 44 percent of all the races he rode in, with 628 career victories from 1,412 starts. He won the American Derby four times at Washington Park and also won the Kentucky Derby—in 1884 with Buchanan, in 1890 with Riley, and in 1891 with Kingman. He died unexpectedly at age 35 of pneumonia on February 12, 1896. The Isaac Murphy Handicap is held annually in June at Arlington Park in his honor, and it is a race for Illinois-bred fillies and mares, ages three and up. Murphy was the first jockey to be inducted into the National Museum of Racing and Hall of Fame. (Author's collection.)

A trio of Thoroughbreds heads down the stretch at Worth Racetrack in 1903. Built in 1898, Worth was located 16 miles southwest of Chicago's Loop at 111th Street between South Ridgeland and South Central Avenues. Worth Racetrack attracted many racing fans who could get to the South Side track easily via the Wabash, St. Louis and Pacific Railroad train stop that was built there in 1902. (Courtesy of the Worth Historical Society.)

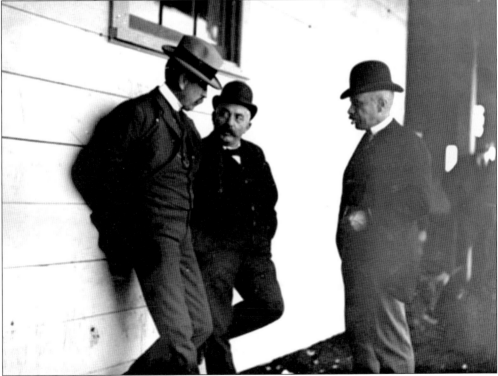

Horsemen Tom Ryan, Dutch Roller, and Charles E. Brossman discuss their horses in the Worth Racetrack paddock area in 1902. Settlement had increased in the communities of Worth and nearby Chicago Ridge, which benefitted from the economic influence of the racetrack, providing many jobs to newcomers. The town of Worth got its name from William Jenkins Worth, a general in the Mexican War. (Courtesy of the Worth Historical Society.)

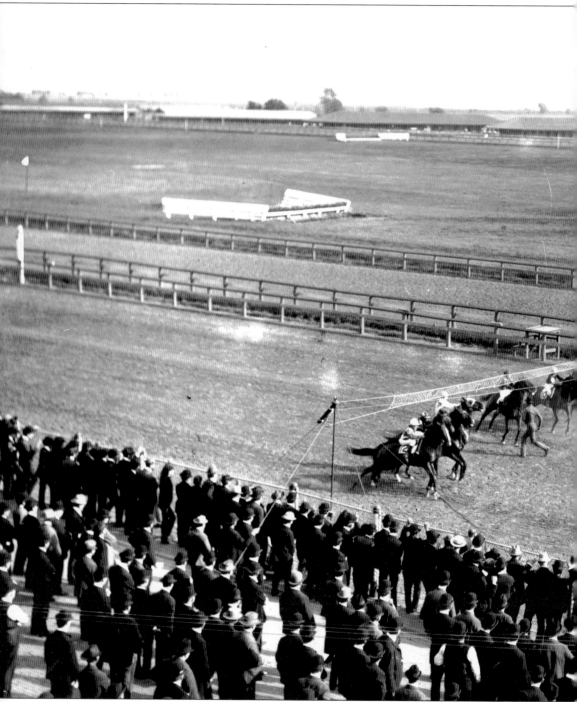

Horseman Edward Corrigan purchased 119 acres of land in Cicero in 1890 and opened Hawthorne one year later, on May 20, 1891. A crowd of 6,000 was on hand to watch the featured Chicago Derby won by Brookwood, owned by Corrigan. Hugh Penny was the leading rider, Johnny Rodegap the leading trainer, and Corrigan the leading owner during the inaugural 27-day spring meeting. This same trio repeated their titles during that year's 41-day summer

meeting. On May 30, 1902, the grandstand burned to the ground, but the track still held a 12-day summer meeting, beginning on August 18. Here Thoroughbreds are released by the official starter (on the white podium just in front of the starting webbing) for the start of the third race at Hawthorne in 1902. (Courtesy of Hawthorne Race Course.)

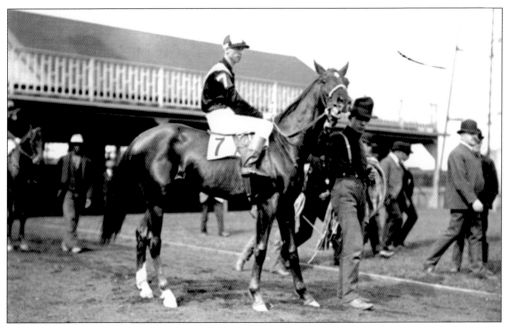

The Thoroughbred racehorse Benificient and his jockey are led by his caretaker from the Worth Racetrack paddock and saddling area in 1903. The striking dark chestnut, with the white star on his forehead and two white socks on his hind legs, is a beautiful example of the athletic confirmation of the classic American Thoroughbred. (Courtesy of the Worth Historical Society.)

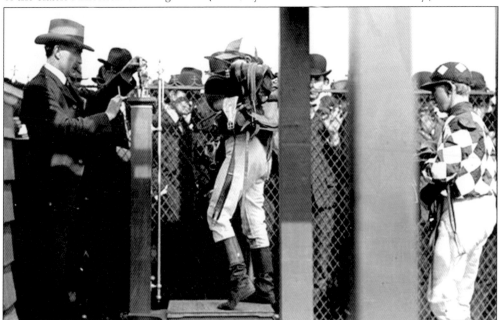

A jockey—his racing tack in hand—steps onto the official scales as the clerk of scales (left) checks his weight, while spectators look on. Another rider waits his turn at the right, near the Worth Racetrack winner's circle during the Thoroughbred meeting in 1903. Horses are assigned specific weights they must carry in races, and jockeys must weigh in both before and after each race. (Courtesy of the Worth Historical Society.)

Thoroughbred trainer Phillips holds the bridle of the animated stallion English Lad while an assistant adjusts the horse's saddle at Worth Racetrack in 1904. A foal of 1901, English Lad, a son of Requital—English Lady—Miser, won the one-and-a-quarter-mile Chicago Derby that year at Hawthorne and had also won the five-and-a-half-furlong Hyde Park Stakes at Arlington one year prior. (Courtesy of the Worth Historical Society.)

Jockeys William "Monk" Coburn and Luther Henry pose confidently on the top of the paddock and saddling area at Worth Racetrack in 1904. One year later, all Chicago racetracks would be shut down due to an ordinance enacted by Mayor Hempstead Washburne in order to curtail gambling in Illinois. The ban on horse racing would remain intact until 1922. (Courtesy of the Worth Historical Society.)

Golden Rule, a chestnut gelding sired by Golden Garter (GB), out of the American-bred mare Lucille Murphy, strides out on his way to the Worth racing oval in 1903. With jockey Luther Henry in the saddle, Golden Rule is wearing a racing hood and D-ring bit that is still commonly used on racehorses today. (Courtesy of the Worth Historical Society.)

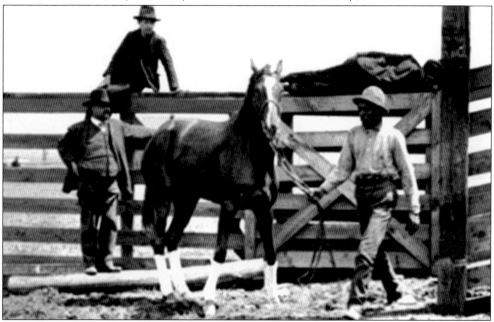

English Lad is being led from the railroad ramp en route to the Worth Racetrack barn area in 1904 by his caretaker Charles Soules. During those days, horses were imported into the United States via ship from Europe, South America, or elsewhere and were then loaded onto special railroad cars for their journeys to racetracks throughout America. (Courtesy of the Worth Historical Society.)

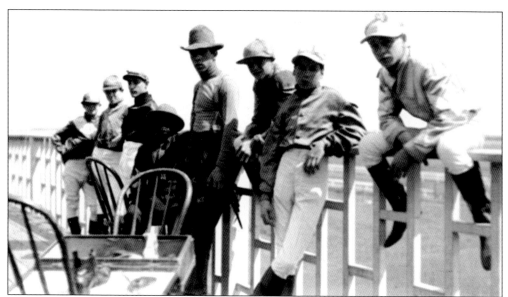

This is a group portrait of jockeys atop the roof of the Worth Racetrack paddock in 1904 in between races. From left to right are jockeys W. Waldo, C. Kelley, L. Dailey, an unidentified African American valet, an unidentified Caucasian valet, and jockeys David Davidson, ? Neeley, and ? Otis. Jockeys in those days had no insurance if they became injured, and accidents often ended a rider's career and in some cases, his life. (Courtesy of the Worth Historical Society.)

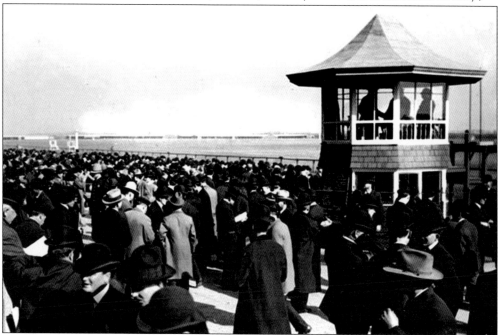

The Worth Racetrack grandstand is crowded with spectators in 1904. The official's stand was located just before the finish line on the racetrack apron, as was typical of most racetracks in the United States then, before the days of sophisticated photo-finish cameras. The stewards of the time were responsible for deciding the order of a close finish that in some cases was decided by a neck, a nose, or a whisker. (Courtesy of the Worth Historical Society.)

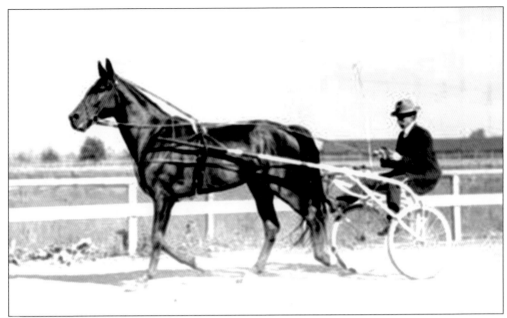

In this photograph, the great pacer Dan Patch takes a stroll over a Chicago oval for trainer Marion W. Savage in 1905. One year later, at the Minnesota State Fair, Dan Patch would electrify the world with his record clocking of 1:55 for the mile, establishing a new world record for pacers. He raced until 1910 at county fairs throughout the United States, traveling in his own private railway car. (Author's collection.)

Here is a view of the defunct official's tower, overgrown apron, and dilapidated grandstand of the old Worth Racetrack in a photograph taken on October 23, 1915. Unfortunately, most of Worth's stabling area and other racetrack-related facilities were torn down in 1911. Today that area is the site of the Holy Sepulchre Cemetery. (Courtesy of the Worth Historical Society.)

Two

GLORY DAYS
THE 1920S, 1930S, AND 1940S

Arlington Park opened on October 13, 1927, through the efforts of California businessman Harry D. "Curly" Brown. The announcer that inaugural season was the immortal Clem McCarthy, who later gained fame as a race caller for NBC Radio. Pari-mutuel gambling was legalized that year, spurring a wave of racetracks being built throughout North America. Here Thoroughbreds walk onto Arlington's track from the tunnel that connects to the saddling area. (Author's collection.)

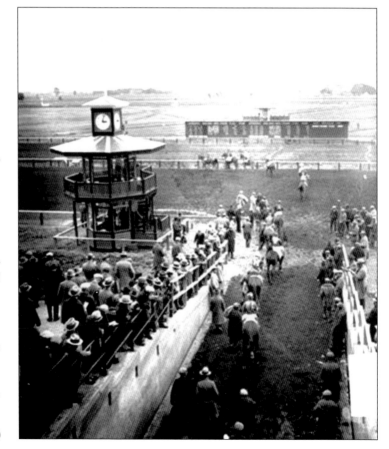

When the ban on racing was lifted in Illinois, it gave the Midwest racing scene an incredible boost, and horses from throughout North America and abroad were shipped to Chicago for major events. One such Thoroughbred was the racehorse Boot to Boot. The British-bred son of North Star—Padula—Laveno relaxes in his stall at Washington Park after wining the 1926 American Derby, a 10-furlong test. This dark bay horse was a multiple stakes winning and placed competitor who earned $120,954 in his career with a 12-9-4 record from 39 starts. Below, he is shown with a garland of flowers draped over his neck, in the Washington Park winner's circle. (Courtesy of Balmoral Park.)

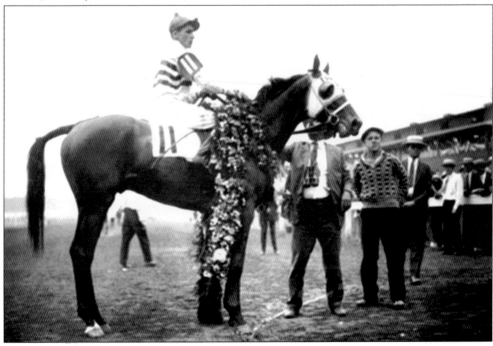

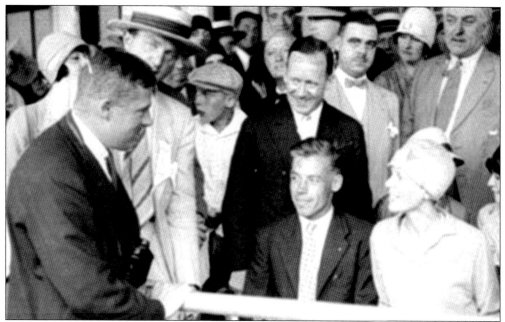

Lincoln Fields (now Balmoral Park) was a place to see and be seen in the late 1920s, and celebrities flocked there. In this photograph, world-famous aviatrix Amelia Earhart visits the Crete oval on July 19, 1928, sitting in the front row of box seats to watch a race named in her honor. Earhart was the first woman to cross the Atlantic Ocean by airplane. (Courtesy of Balmoral Park.)

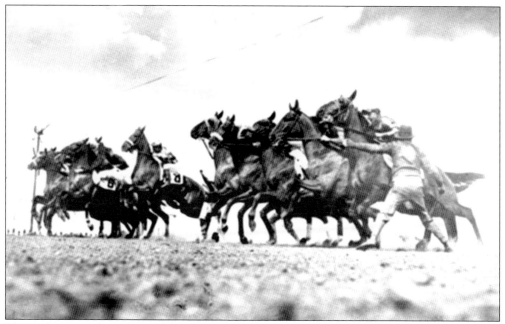

This is the start of a race at Arlington in 1927. In those days, the common webbing, or tape, was used to start a race, as the modern-day starting gate had not yet been introduced to Thoroughbred racing. Jockey Joe Bollero won the first race ever contested at Arlington, aboard Luxembourg. Bollero later became a successful trainer. (Author's collection.)

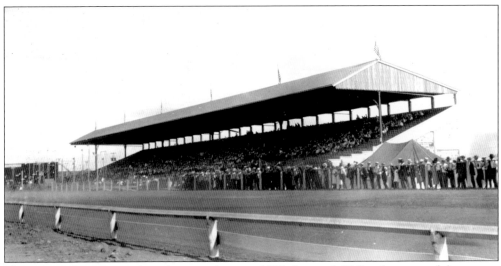

The Aurora Downs grandstand is seen here in 1928. Located 37.5 miles west of downtown Chicago, Aurora had its inaugural, four-day meeting on July 21, 1891. After the wagering ban was lifted in 1905, Aurora reopened in 1923 as a half-mile harness track. In 1925, Col. E. J. Baker of St. Charles initiated the $25,000 Chicago Trotting Derby, but during the 1930s, Aurora was strictly limited to Thoroughbred racing. (Courtesy of Kathy Parker.)

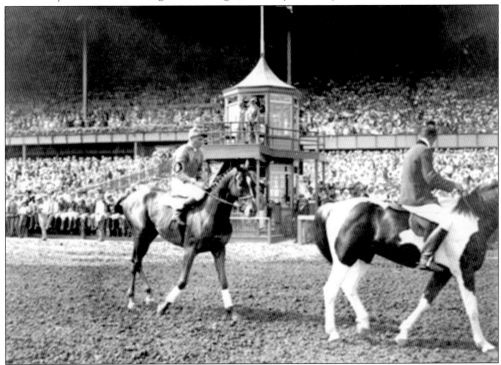

Reigh Count and jockey Chick Lang are seen at Washington Park in 1928. Reigh Count was the Virginia-bred son of Sunreigh—Contessina—Count Schomberg and owned by Fannie Hertz. At age three he won the Kentucky Derby and Horse of the Year honors, and retired with $180,795 in earnings. As a stallion he produced 1943 Triple Crown winner Count Fleet. Reigh Count died in 1948 at age 23. (Author's collection.)

A cigar seller at Lincoln Fields in 1929 touts Perfecto Garcia Cigars to the patrons. Early investors in Lincoln Fields included Marshall Field, founder of Field's Department Store, and Edward J. Fleming, president of Fleming Coal Company. Sen. Edward Hughes, Illinois secretary of state from 1932 to 1944, was the vice president of Lincoln Fields during the racetrack's early years. (Courtesy of Balmoral Park.)

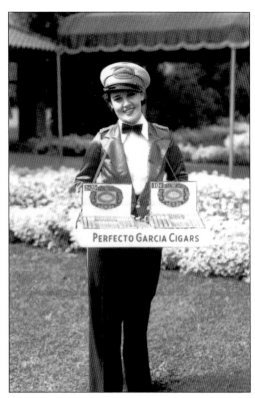

Clyde Van Dusen, the gelded son of Man O'War Uncle's Lassie, won the 55th Kentucky Derby and $122,402 lifetime. Named for his trainer, shown here leading him at Lincoln Fields in 1929, Clyde Van Dusen was the only horse in the first 134 years of the derby to win from post 20 until Big Brown did so in 2008, and the only gelding to win the derby until Funny Cide in 2003. (Courtesy of Balmoral Park.)

An unidentified jockey and friend stand beside a car in front of the Lincoln Fields grandstand, which still exists today. In 1925, Col. Matt J. Winn of Kentucky purchased 1,050 acres south of Crete along Hubbard's Trail (Route 1) and established Lincoln Fields (now Balmoral Park) at a cost of $2 million. Before pari-mutuel wagering was legalized in 1927, Lincoln Fields utilized the certificate (paper) system. (Courtesy of Balmoral Park.)

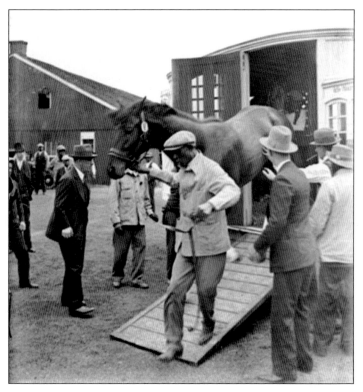

Blue Larkspur is led down the ramp from his trailer at Lincoln Fields in 1929. The rangy bay colt was named the 1929 Horse of the Year and was conditioned by Herbert "Derby Dick" Thompson, winning the Stars and Stripes Handicap and the Arlington Cup. He retired with 10 wins and $272,070 in earnings and was a prolific stallion until his death in 1947. (Courtesy of Balmoral Park.)

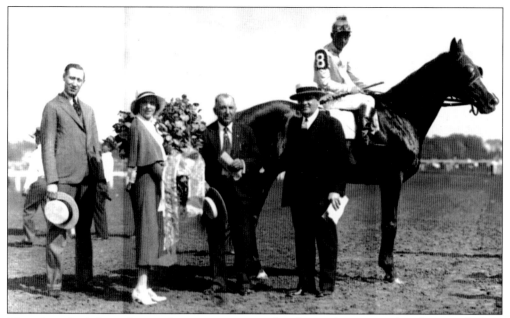

The winner's circle is always a happy occasion, and such was the case in this photograph from Lincoln Fields in 1928, as horse and jockey celebrate with the winning trainer and owners. The Crete facility attracted some of North America's top horses, due to the popularity of its $6,000 Joliet Stakes—the first ever race in Illinois for two-year-old colts and geldings. (Courtesy of Balmoral Park.)

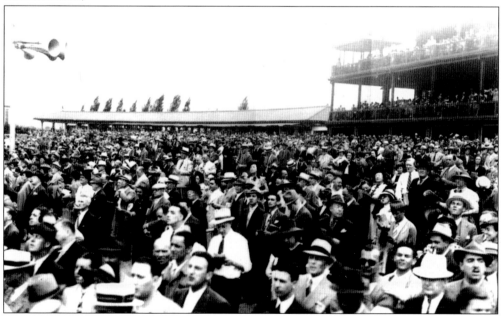

Huge crowds were commonplace at Lincoln Fields in the 1920s and 1930s, as horse racing was one of the most popular spectator sports in North America. Top horses like Sun Beau, King Nadi, and Chance Play all competed at Lincoln Fields, while leading stables such as Calumet Farm maintained barns there. Jockeys Earl Sande, George Woolf, and Eddie Arcaro were also familiar faces at the Crete facility. (Courtesy of Balmoral Park.)

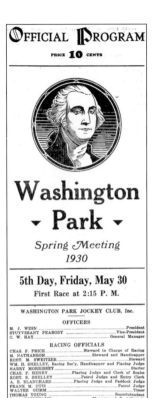

A Washington Park program from May 30, 1930, sold for a cost of 10¢. Washington Park had reopened at a new location on July 3, 1926, just west of Halsted Street on 175th Street, outside the Homewood village boundaries. A spur line was built between Chicago and Washington Park by the Illinois Central Railroad to accommodate fans. (Courtesy of the Homewood Historical Society.)

Earl Sande, with an equine friend at Lincoln Fields in 1930, was a top jockey in the 1920s and 1930s. Sande began riding in 1917, steering such horses as Man O'War, Zev, Gallant Fox, and Sir Barton. He won three Kentucky Derbies and five Belmonts and was the nation's leading rider in 1921, 1923, and 1927. A member of racing's hall of fame, Sande died in 1968. (Author's collection.)

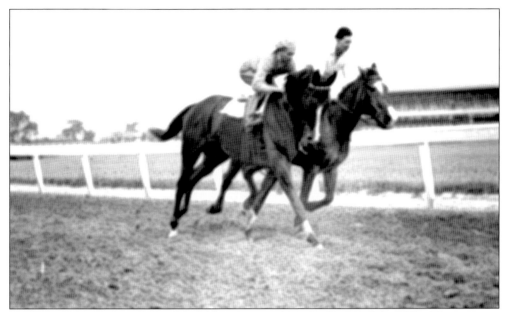

Gallant Fox works out at Lincoln Fields in 1930. The son of Sir Gallahad III—Marguerite—Celt was the 1930 Triple Crown winner and champion sophomore colt. He is the only Triple Crown winner to sire a Triple Crown winner (Omaha). Trained by "Sunny" Jim Fitzsimmons for Belair Stud, Gallant Fox was ridden by Earl Sande. Gallant Fox was inducted into racing's hall of fame in 1957. (Author's collection.)

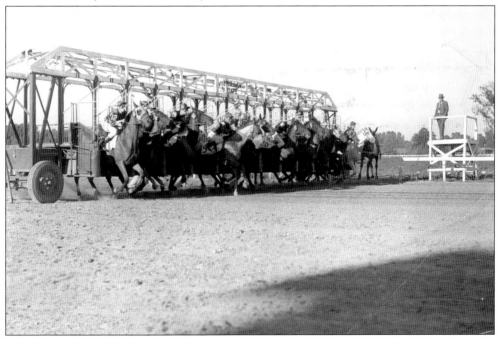

Thoroughbreds bolt from the starting gate at Lincoln Fields sometime in the 1930s. Note that a team of mules was used to pull the starting gate off the racing surface and into the infield after the start of the race. Electronic starting gates would not become the norm until almost a decade later. (Author's collection.)

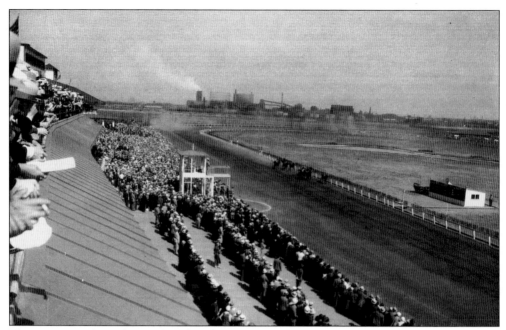

This is a view from the roof of the Sportsman's Park clubhouse on May 5, 1932. The new, half-mile Thoroughbred oval was constructed at the site of the old quarter-mile Hawthorne Kennel Club. The seven-year-old King Halma, ridden by Eddie Johnson, won the first race, a six-and-a-half-furlong test, when the meet opened on May 2, 1932. (Author's collection.)

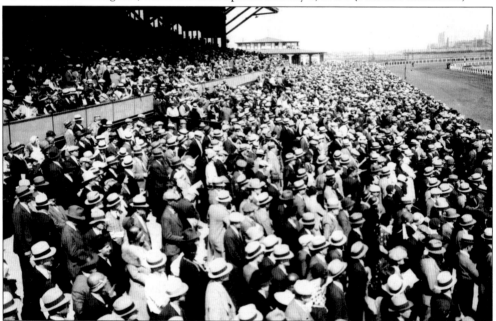

Fans pack the grandstand, clubhouse, and apron at Sportsman's Park on May 12, 1932. Attorney Edward J. O'Hare converted the former Hawthorne Kennel Club from a quarter-mile greyhound track into the half-mile Sportsman's Park, which would remain his until it was sold to the Bidwell family in 1943. Over the years, it has been suggested that mobster Al Capone was actually responsible for funding the building of Sportsman's Park. (Author's collection.)

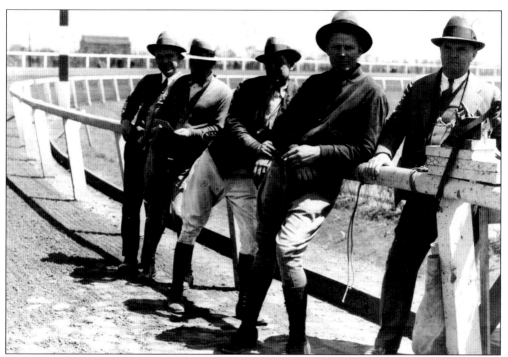

The Sportsman's Park starting gate crew relaxes in between races at the top of the half-mile homestretch. Starting gate assistants, from left to right, B. S. Smith, Jack Hennessy, Eddie Pressie, Jack Hernouse, and gate chief Tom Brown worked diligently to get horses off to a clean and prompt start. Prior to the introduction of the starting gate, web barriers were used. (Courtesy of Hawthorne Race Course.)

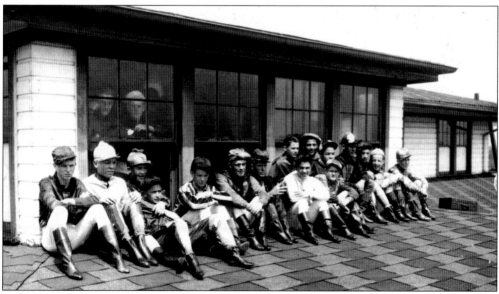

Jockeys sit on the rooftop of the Sportsman's Park jockey's quarters on May 12, 1933. Third from the right is Eddie Arcaro, who won his first Sportsman's Park race with Piecemeal on October 10, 1932. Arcaro captured every major stake in North America and is the only jockey to have won two Triple Crowns, aboard Whirlaway in 1941 and Citation in 1948. (Author's collection.)

On May 13, 1932, Thoroughbred fans either drove to Sportsman's Park or took the Illinois Central Railroad train to the racetrack. The train tracks are visible just beyond the telephone poles, on the north side of the racetrack. This parking area was later used to extend the half-mile track into a five-eighths-mile and later a seven-eighths-mile oval reaching to Cicero Avenue at the east. (Courtesy of Sportsman's Park.)

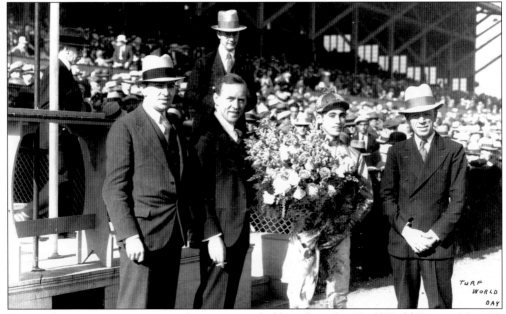

During the opening season, special events were held, such as this Turf World Day on May 19, 1932, at the new Sportsman's Park. That year the first trainer on the grounds was Chester Adams and the first horse was Daiquiri. Jockey Johnny McLaren would nab the title of leading rider of the National Jockey Club that year at Sportsman's Park. (Courtesy of Sportsman's Park.)

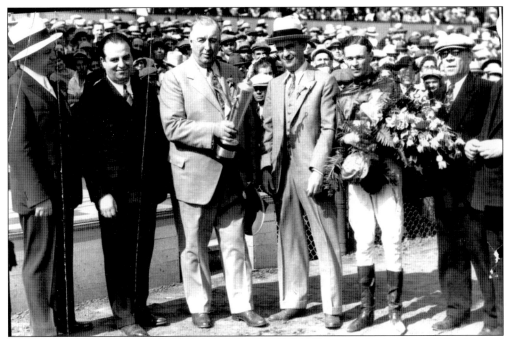

Big Bill Thompson Day was held on May 13, 1932, at Sportsman's Park. "Big Bill," otherwise known as William Hale Thompson (third from left), was mayor of Chicago from 1915 to 1923 and 1927 to 1931. He was the last Republican to serve as mayor, as the city's 41st and 43rd mayor. Allegedly, it was through gangster Al Capone's support that Thompson got reelected in 1927. (Courtesy of Sportsman's Park.)

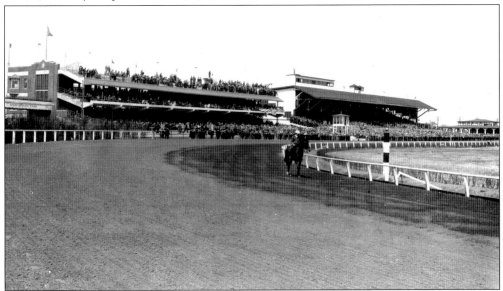

On May 20, 1932, the first Thoroughbred meeting ever held at Sportsman's Park draws a plethora of patrons from the city of Chicago. Here a lone outrider and his pony take a stroll around the first turn of the half-mile oval that butted up against Laramie Avenue to the west, Cicero Avenue to the east, railroad tracks to the north, and Hawthorne to the south. (Courtesy of Hawthorne Race Course.)

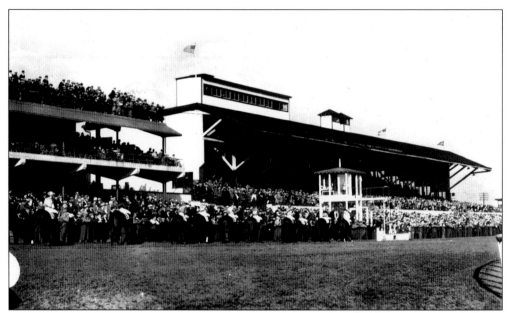

Thoroughbreds line up just after a race in front of the Sportsman's Park clubhouse and grandstand on October 20, 1932, during the new racetrack's fall meeting. The facility, built at a cost of over $2 million, was considered to be one of the most state-of-the-art racetracks in North America at the time. (Courtesy of Hawthorne Race Course.)

Sportsman's Park was definitely the place to be in the fall of 1932. This photograph, from October 10 of that year, was taken from the top of the jockey's quarters and saddling area or paddock and faces the grandstand with the clubhouse at the far end, near Laramie Avenue. (Courtesy of Sportsman's Park.)

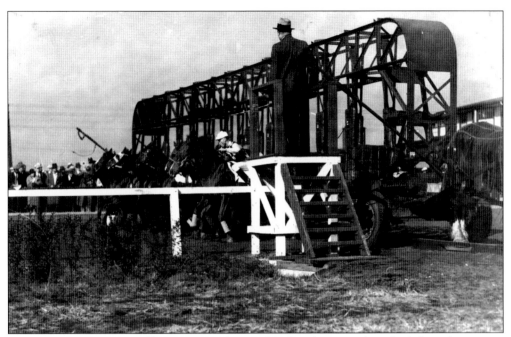

Sportsman's Park starter Billy Meyer says the word "go" and runners disembark from the starting gate on October 24, 1932. In those days, the starting gates were pulled by a mule team, or by draft horses, back into the racetrack infield. The draft horse can be seen at the far right in the photograph, dressed in a traditional fly sheet of the times. (Author's collection.)

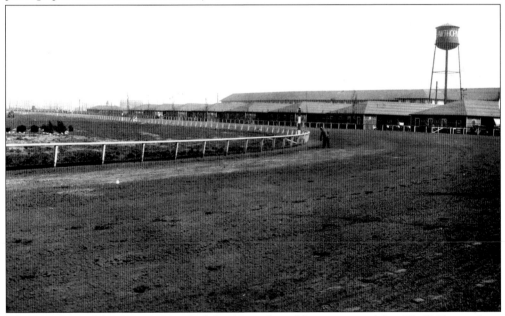

This is a view of the Sportsman's Park backstretch and barn area on May 18, 1933, as a lone member of the track crew rakes the area near the rail. Notice how the Sportsman's Park barns sit directly up against Hawthorne's grandstand. Allegedly, Al Capone and Edward J. O'Hare had wanted to buy into Hawthorne, but were denied partnership, and thus reconfigured the old dog track (Hawthorne Kennel Club) into a horse racing oval. (Author's collection.)

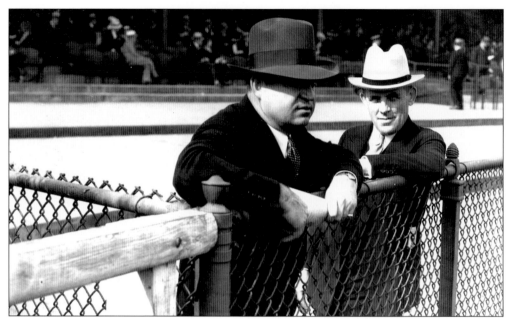

Al Capone and friend attorney Edward J. O'Hare operated their dog track, Hawthorne Kennel Club, just to the north of Hawthorne, after the Carey family allegedly denied Capone a partnership in their facility. Dog racing was illegal in Illinois then and still is. When Capone and O'Hare were forced to shut down their dog track, they erected Sportsman's Park, thus giving Hawthorne direct competition for the first time. (Courtesy of Hawthorne Race Course.)

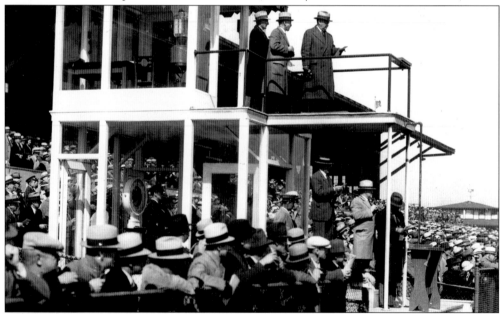

Here is a close-up view of the apron, scales, and steward's booth at Sportsman's Park on May 6, 1933. As racing became more sophisticated, racetracks began introducing state-of-the-art devices, such as electric tote boards, photo-finish cameras, and starting gates. Arlington Park was the first track in Illinois to utilize the first all-electric totalisator in 1933. (Courtesy of Hawthorne Race Course.)

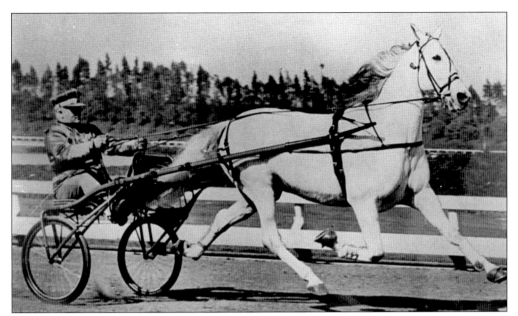

Greyhound, the finest trotter of the 1930s, was owned by Col. E. J. Baker of St. Charles and trained by his driver Sep Palin. A $900 yearling purchase, Greyhound won nearly every major trotting race—including the 1935 Hambletonian—from 1934 through 1940 and demolished all existing trotting records, in addition to trotting 24 miles under 2:00. Greyhound retired with $38,952 in his coffers. (Author's collection.)

In 1934, Thoroughbred stewards George W. Schilling (left), Christopher J. Fitzgerland, and Joseph J. Graddy oversaw the running events in Chicago. Here these three are atop the steward's stand at Sportsman's Park looking for racing infractions incurred by rough-riding jockeys. That season, legendary jockey Johnny Longden captured the leading rider title at the Cicero half-miler. (Courtesy of Hawthorne Race Course.)

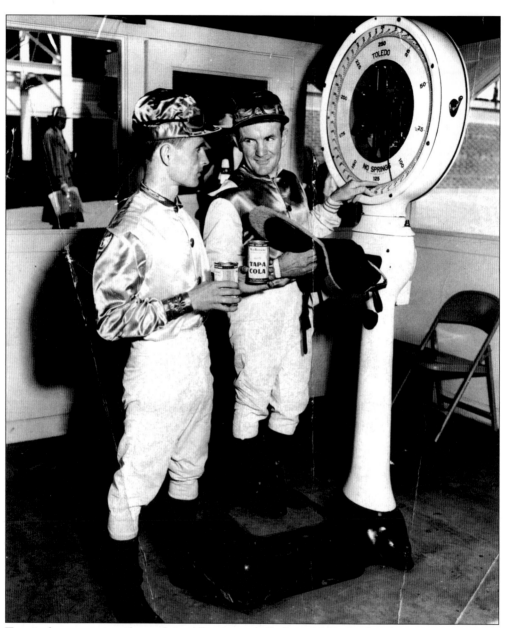

Two jockeys examine the scales at Sportsman's Park in 1934. Both riders are wearing silk caps, which were commonplace long before mandatory safety rules were instituted requiring all jockeys to wear protective headgear in the 1960s. Jockeys are required to weigh in before and after each race, with their racing tack (saddle) in hand. As well, they are not permitted outside the racing areas—such as the grandstand, clubhouse, or other public areas—wearing silks and are not permitted to wager on any other horse, besides the one they are riding, in a race. Typically, jockeys start out riding at a young age, becoming apprentice or "bug" riders for the first year they ride professionally, before becoming a journeyman jockey. Apprentices get a weight allowance, and thus, many trainers will choose to ride them on their horses, as five pounds can make a great deal of difference to a horse when it comes to winning or finishing second or third. (Author's collection.)

Starter Tom Brown and his starting gate crew are seen at Hawthorne in 1934. During those years, when starting gates were first introduced, they did not have front or back panel doors, and horses just stood in between padded divisions. Clay Puette, a rider and starter at West Coast tracks, invented the modern starting gate, which replaced the web barriers and chalk lines that were utilized in the early years of racing. (Courtesy of Hawthorne Race Course.)

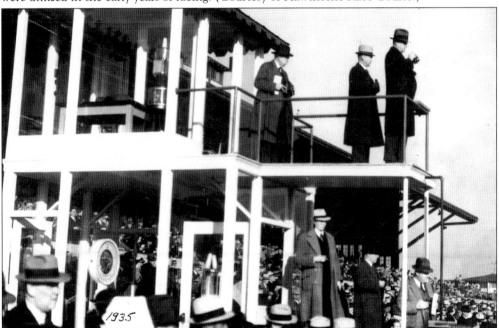

The stewards at Sportsman's Park stand atop a viewing stand on the apron, just in front of the grandstand. Prior to the installation of a photo-finish camera, this was a common practice by most stewards and race judges throughout North America. The height of their platform allowed them to have a clear view of the racetrack and, most importantly, the homestretch, where infractions might occur. (Courtesy of Hawthorne Race Course.)

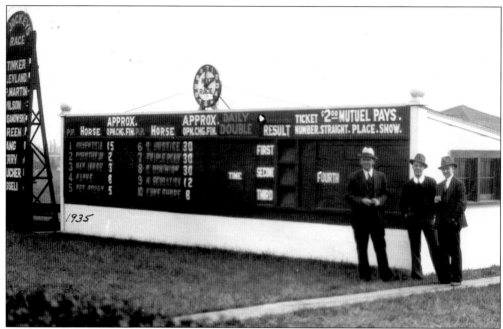

The Sportsman's Park tote board is seen here in 1935. In those days, most tote boards were operated by hand, with a crew located inside the building that changed the odds, numbers, prices, and horse's and jockey's names manually. In 1933, Arlington Park was the first racetrack in Illinois to install an all-electric totalisator, which allowed the racetrack to determine the volume of betting and the amount wagered on each horse. (Courtesy of Sportsman's Park.)

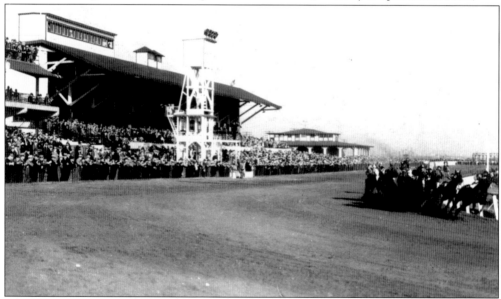

A full field of Thoroughbreds tears around the first turn at Sportsman's Park in 1936. That season, Arlington, Hawthorne, Lincoln Fields, and Sportsman's Park all installed photo-finish cameras, thus eliminating decisions made by each track's placing judges. Instead, the stewards could now rely on a camera, which took 240 photographs per second to insure a correct decision in close finishes. (Courtesy of Sportsman's Park.)

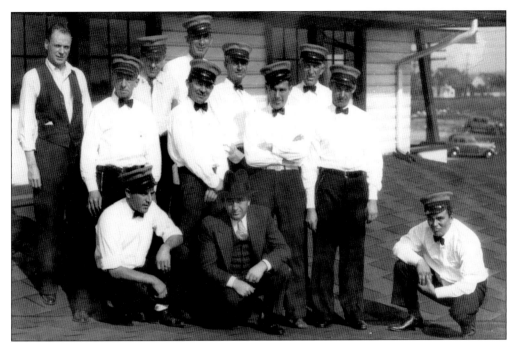

A group of jockey valets poses atop the saddling area or paddock at Sportsman's Park in 1936. Valets are employed by jockeys to attend to their needs in the jockey's room and after each race. A valet will return a jockey's riding equipment to his storage locker, wash his racing silks and pants, and keep his riding boots well oiled. Valets receive a percentage of what a jockey earns for riding each horse. (Courtesy of Hawthorne Race Course.)

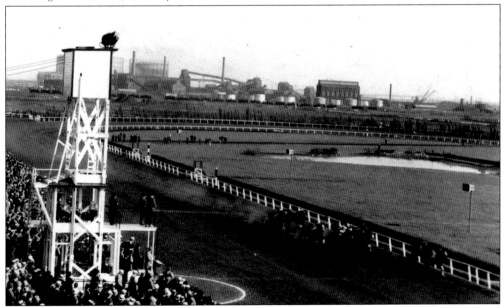

The view from atop the Sportsman's Park clubhouse roof in 1936 presents a different perspective of a Thoroughbred race and clearly shows the final turn and infield of the half-mile oval, as well as the steward's stand just in front of the winner's circle. Racing continued to flourish in the years leading up to World War II in the Windy City. (Courtesy of Hawthorne Race Course.)

THE WASHINGTON PARK FUTURITY
To be run Saturday, June 26

PRICE 10 CENTS

Racing programs and wagering became more sophisticated by the late 1930s, as evidence by this Washington Park program from 1937. That same year, Hawthorne handled $7,557,896 over its 24-day meeting, the largest amount ever handled over the same time frame at a Chicago track. As well, Arlington Park debuted its daily double wager for the first time on June 28. (Courtesy of the Homewood Historical Society.)

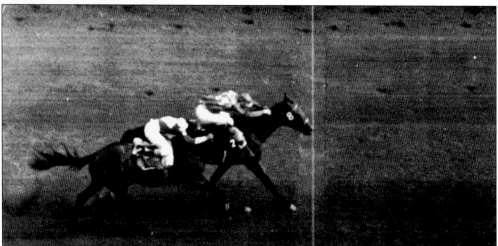

Arlington Park was the first racetrack in the Windy City to install a photo-finish camera in 1936. Coined the "Eye in the Sky," the photo-finish camera utilized a high-speed motion picture camera to determine tight finishes, as evidenced in this July 22, 1939, photograph from Arlington Park. (Author's collection.)

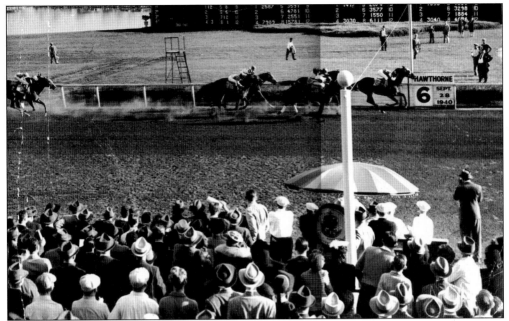

A field of Thoroughbreds glides under the finish line in the sixth race on September 28, 1940, at Hawthorne Race Course in Stickney. That same season a new Bahr starting gate, with stall doors that opened and closed electronically, debuted at Hawthorne. Note the jockey scales that were located directly in front of the finish line at the time. (Author's collection.)

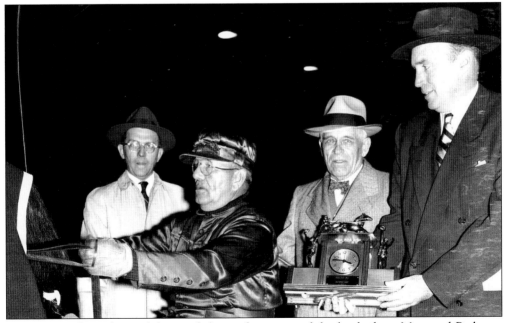

Arthur T. Galt Sr. (second from right) was the owner of the land where Maywood Park was erected. Born in Chicago in 1876, this lawyer, real estate developer, and amateur driver established the first harness-only racetrack in 1946. Maywood has conducted a harness meeting every year since, the longest in the state's Standardbred history. In 1947, Maywood became the first U.S. racetrack to televise its harness program. (Author's collection.)

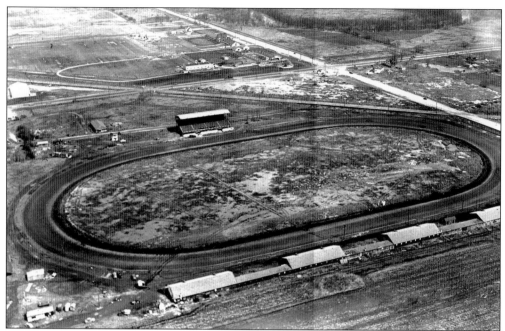

Maywood Park is located nine miles west of Chicago between Fifth and First Avenues, just north of the Maywood and Melrose Parks communities, south of Villa Park and east of Stone Park. North Avenue, one of the longest city streets in the Windy City, is just north of the grandstand. A railroad line diagonally crosses First, North, and Fifth Avenues, heading toward O'Hare Airport, in this 1946 photograph. (Courtesy of Duke Johnston.)

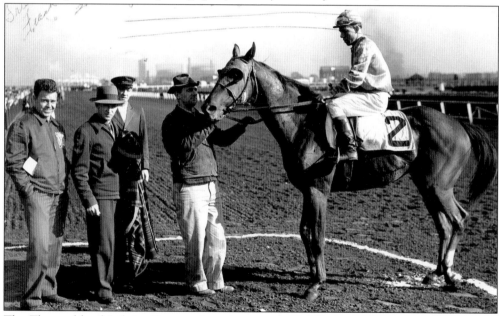

The Thoroughbred Infinity K romped to victory in a $2,000 overnight event at Sportsman's Park and then posed for the track photographer on November 6, 1947. Jockey T. Williams was in the irons for trainer Thomas Swigert and owner Mrs. M. Swigert, as the colt was clocked in 1:26.2 for the six-and-a-quarter-furlong test. (Author's collection.)

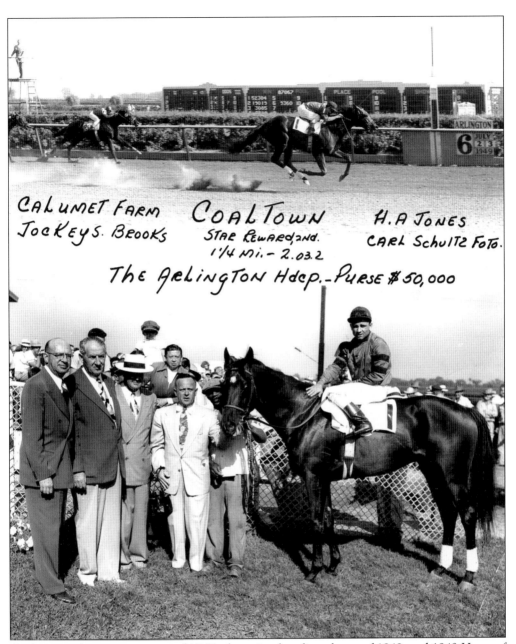

Coaltown—champion sprinter of 1948, champion handicap horse of 1949, and 1949 Horse of the Year—roared to a three-length victory in the $50,000 Arlington Handicap on July 23, 1949. Coaltown covered the one-and-a-quarter-mile test in 2:03.2 with S. Brooks in the saddle. This son of the great Bull Lea went on to win 23 races and earn $415,675. He was trained by H. A. "Ben" Jones for the famed Calumet Farm. In 1948, Coaltown finished second in the Kentucky Derby to stablemate and eventual Triple Crown winner Citation. He later began his stud career at Calumet Farm and was exported to France in 1955. He died at age 20 in 1965 and was inducted into racing's hall of fame in 1983. This photograph is what the winning connections received for their victory, similar to the winner's circle photographs produced by present-day track photographers. (Author's collection.)

Illegal gambling was common during the first half of the 20th century in the Windy City. Wagering on horse racing was big business, and professional bookies often had over 50 telephone lines at their disposal in order to ply their wares. At one time, Chicago was thought to have as many as 1,000 illegal gambling houses in the city where fans could place their wagers with bookies. (Author's collection.)

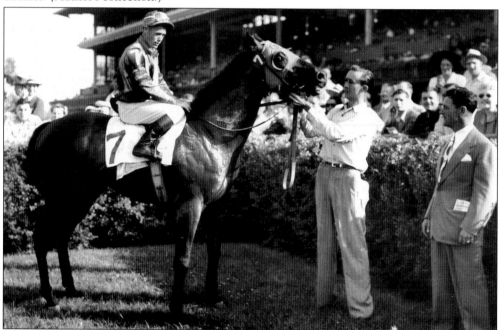

With Pleasure set a new track record of 1:09.4 for six furlongs at Washington Park on July 28, 1947, in the $20,000 Quick Step Stakes. Jockey A. Snider was in the saddle for trainer J. P. Fleming and owner Brolite Farm. With Pleasure was a foal of 1943 who won 15 races and $280,660 during his career. (Author's collection.)

Three

SWING TIME
THE 1950S AND 1960S

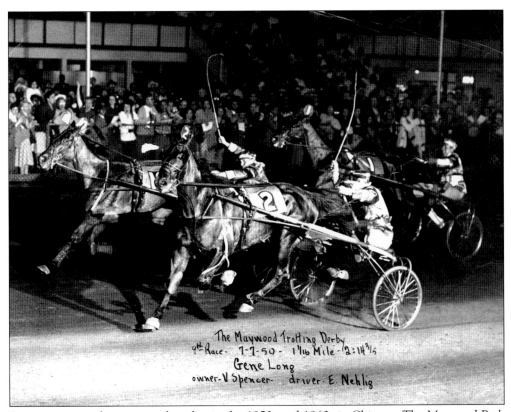

The Maywood Trotting Derby
4th Race- 7-7-50 - 1 1/16 Mile - 2:14 3/5
Gene Long
owner- V. Spencer driver- E. Nehlig

Racing continued to grow and evolve in the 1950s and 1960s in Chicago. The Maywood Park Trotting Derby was one of the highlights of Windy City harness racing contests in 1950. The one-and-one-sixteenth-mile contest was won by Gene Long (2), driven by E. Nehlig to a 2:14¾ clocking for owner V. Spencer. (Author's collection.)

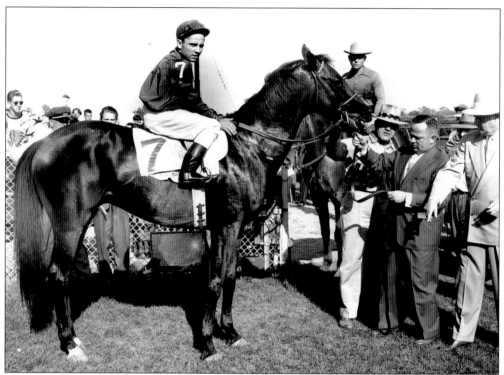

Ponder captured many stakes during his career, including the $82,400 Arlington Handicap on July 29, 1950, at Arlington Park for jockey S. Brooks. Owned by the historic Calumet Farm, the son of Pensive—Miss Rushin was a foal of 1946 that earned $541,275 for trainer H. A. "Ben" Jones. Ponder became a successful sire, producing the $600,355 winner Needles, who captured the 1956 Kentucky Derby and Belmont Stakes. (Author's collection.)

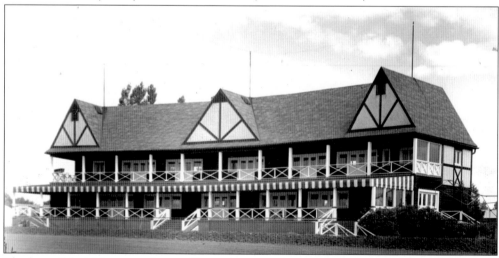

The beautiful clubhouse at Aurora Downs is seen as it looked in the 1950s. Located near the junction of the east–west tollway (Route 88) at Route 31 in North Aurora, Aurora Downs originally opened as a half-mile harness racing oval on July 21, 1891, with a four-day meeting. It was the first Chicago track to reopen (in 1923) when the wagering ban was lifted one year prior. (Courtesy of the *Horseman and Fair World*.)

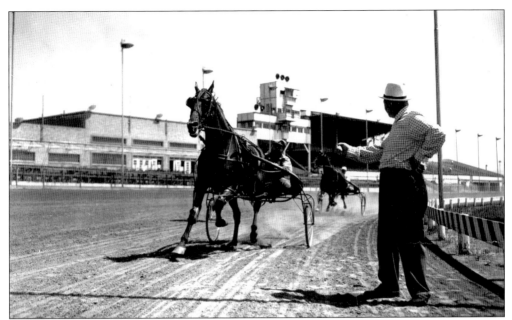

A pair of pacers speeds around Maywood's first turn during morning training hours in 1950, while a timer stands near the hub rail holding a stopwatch. The low, wooden hub rail was used traditionally for harness racing at the time. Years later, the rail would morph into the type used for Thoroughbred racing until the early 1990s, when the Euro-rail, or pylons, were installed at harness tracks nationwide. (Courtesy of Maywood Park.)

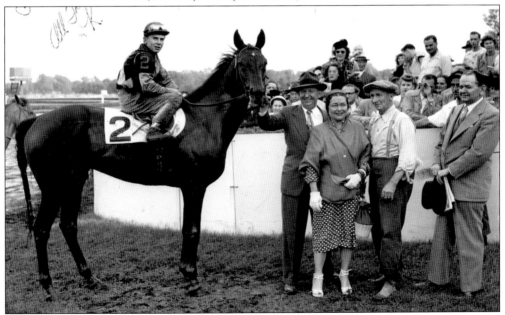

The 1950 Washington Park Handicap sported a purse of $54,550. That year the victory went to the brown gelding Inseparable, who won the one-and-a-quarter-mile test in 2:06.1 for jockey K. Church, trainer Henry Trotsek, and owner Hasty House Farm. In this photograph, the winning connections celebrate in the Washington Park winner's circle on September 2, 1950. (Author's collection.)

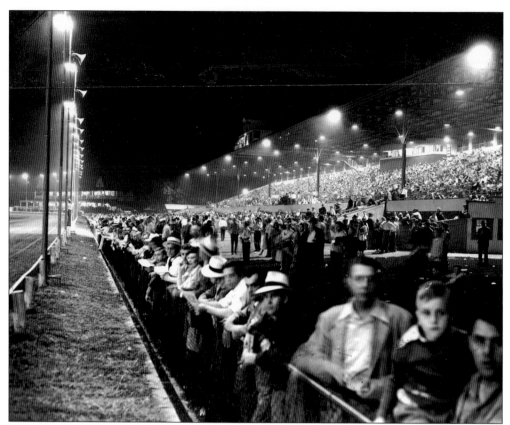

Capacity crowds were common at Aurora Downs in 1947, and harness races were held at that half-mile venue from 1947 through 1951. M. G. Farnsworth, a Chicago merchant and Aurora Downs owner, staged top events at his track and attracted 231,426 fans over 58 racing nights who wagered $4,661,361, an average of $80,000 per night. After the 1951 meet, Aurora was not used again for the "tail sitters" until 1959. (Courtesy of the *Horseman and Fair World*.)

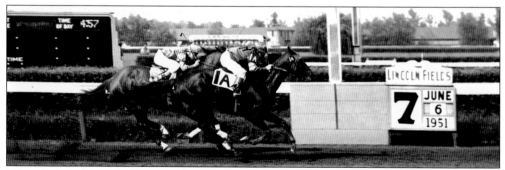

Warsick won the seventh race, a $3,000, six-furlong sprint at Lincoln Fields on June 6, 1951. Jockey John Adams was in the irons for trainer J. L. Oglesby and owner Mrs. M. R. Hughes. The chestnut daughter by War Dog—Sickle Comb was a foal of 1946 that earned $28,915 from 14 wins. Warsick became a successful broodmare, producing the $74,560 winner Sabotage and Warsick Lad, who earned $20,814 in his career. (Author's collection.)

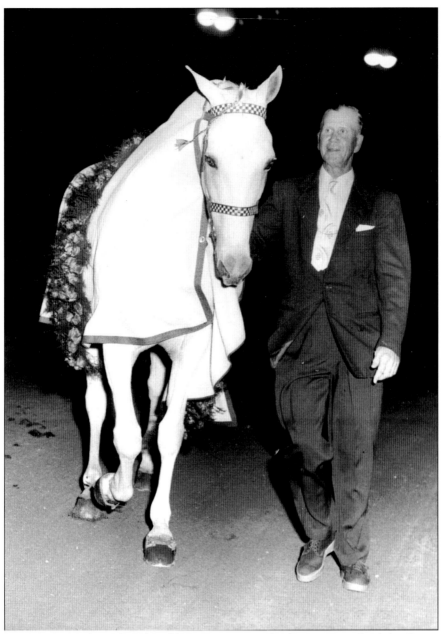

The great trotter Greyhound made public appearances in his later years, as he did at Sportsman's Park with Col. Edward J. Baker on July 11, 1951, at age 19. The tall (16.1 hands), gelded son of Guy Abbey, out of the Peter the Great–mare Elizabeth, was foaled on March 4, 1932, and was just as comfortable under saddle as he was hooked to a sulky, with mounted records of 3:02½ for one and a half miles in 1937, 4:06 for two miles in 1939, and 2:01¾ for one mile in 1940. Greyhound trotted 25 career 2:00 miles and at one time held 14 world records. He was retired in 1940 to Colonel Baker's farm in St. Charles and continued to have visitors until his death on February 4, 1965. He was buried at the privately owned Red Gate Farm in St. Charles. Greyhound was later named outstanding trotter of the 20th century in a membership poll by the Harness Racing Hall of Fame of the Trotter. (Author's collection.)

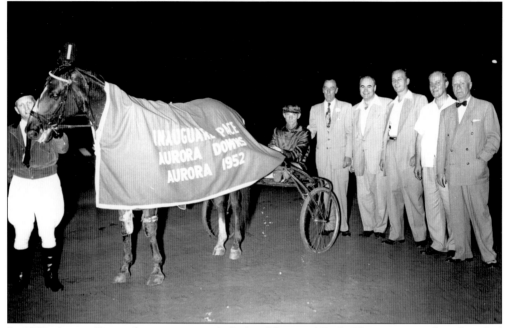

In 1952, Aurora Downs harness racing shifted to Maywood Park. Here a group of unidentified owners stands on a mud-soaked Maywood racetrack after their horse captured the inaugural Aurora Downs Pace. In the fall of 1958, Aurora Downs applied to reopen and was granted a harness racing license by the Illinois Racing Board for the 1959 racing season. (Author's collection.)

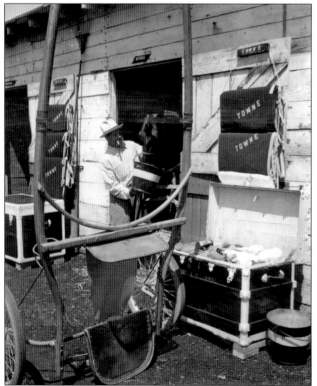

A caretaker gives the pacing mare Attica a sip of water after a workout at Maywood Park in 1952. The daughter of Brookdale—Tru Bell—Truabe took a record of 2:16h that year at Maywood for the Norman C. Towne Stock Farm of Libertyville. Bred in Pana by horseman Carl Preihs, Attica would eventually be sold to Canadian interests as a broodmare. (Author's collection.)

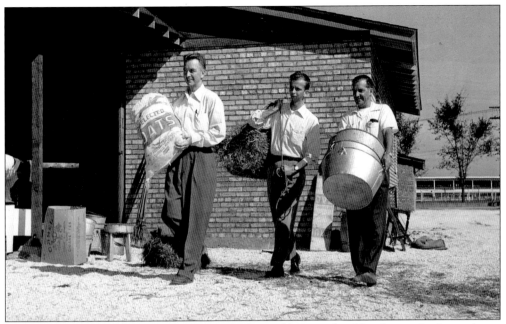

Caretakers carry oats, hay, and tubs into the stables on the Hawthorne backstretch on September 5, 1953. These staples are just a few of the necessary items required to maintain a stable of racehorses. Hawthorne's barns were built in the traditional shed-row style, with a brick foundation, open on one side, to allow the horses to have fresh air and sunshine during the spring, summer, and fall months. (Courtesy of Hawthorne Race Course.)

Harness drivers Billy Rouse (left) and Dee Stover (right) provide Maywood Park's Miss Photoflash with some driving strategies for an upcoming race in this photograph from 1953. During those years, celebrities often visited racetracks, and many owned racehorses of both breeds, including Jimmy Cagney, Bing Crosby, and Mickey Rooney. (Courtesy of Sportsman's Park.)

Harry Burright was one of the top horsemen of his day and began driving and training Standardbreds at age 13. He was born into a harness racing family on September 26, 1916, in Oregon, Illinois, and would drive in his last race at Rushville on June 12, 1983. He was one of the nation's leading drivers from 1948 (at age 32) through the late 1960s and retired with 2,671 winners and $5,069,986 in purse earnings. At one time, he and six other members of his family were active in the sport. In 1956, he and his brother Gene finished in a dead heat to win at Maywood. Throughout his career, he won countless driving titles at Maywood, Aurora Downs, Washington Park, Sportsman's Park, Cahokia Downs, and Kentucky Raceway. Here he relaxes between races while sitting on one of his racing sulkies. (Courtesy of Sportsman's Park.)

B'Haven scored the first 2:00 mile ever paced on an Illinois half-mile track at Sportsman's Park on July 8, 1955. The son of Eddie Havens—Gay Sue—Brookdale, he was the last record holder at Sportsman's half-mile oval, as it was redesigned into a five-eighths the following season. Shown with driver Wilbur Long, B'Haven retired with $229,717 in earnings. He was the first horse inducted into the Illinois Harness Racing Hall of Fame. (Courtesy of Sportsman's Park.)

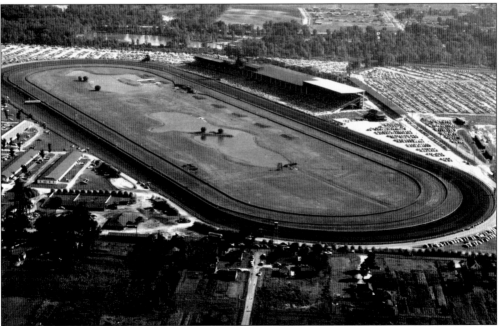

Washington Park is seen at the height of its popularity in the mid-1950s. This aerial view shows the racetrack in its glory. The mile oval is surrounded by rural countryside on Chicago's South Side. The stable area is visible on the backstretch, and huge parking lots are located past the first turn, behind the immense grandstand, and behind the far turn. (Courtesy of the Homewood Historical Society.)

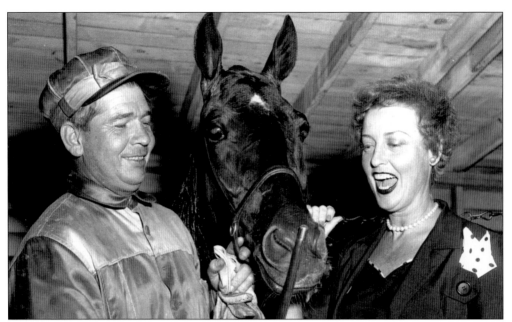

As one of Chicago's leading driver-trainers of the 1950s, Harry Burright was photographed giving some handicapping pointers to stage, screen, and singing star Jeanette MacDonald, who was visiting the Windy City. The venerable pacer Assured seems quite interested in what the talented horseman has to say as well. (Courtesy of Sportsman's Park.)

Nashua gallops at Washington Park in preparation for his match race with Swaps, on August 31, 1955. Owned by Belair Stud, Nashua defeated Swaps easily on that day. Trained by "Sunny" Jim Fitzsimmons, Nashua earned $1,288,565 with 22 career wins. He become a successful stallion, producing 77 stakes winners, and was the first horse ever to be sold for over $1 million. Nashua died in 1982. (Courtesy of the Homewood Historical Society.)

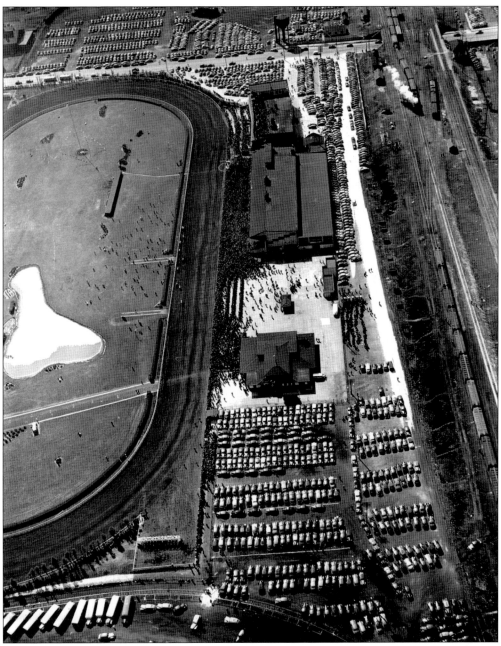

This is an aerial shot of Sportsman's Park in 1956, the first year the track had been reconfigured from a half-mile oval into a five-eighths-mile raceway. In addition, a new concrete and steel grandstand was constructed to replace the one built in 1932, increasing the seating capacity to 15,000. As well, eight new barns, a new track kitchen, and a new press box were built—all at a cost of $2.4 million. Thoroughbreds are visible on the track as they head down the homestretch, and the grandstand, clubhouse, and apron are all overflowing with fans, which is also verified by the great number of automobiles seen in the track's parking lots. Laramie Avenue is visible at the top of the photograph, and the railroad tracks are at the right and at the bottom of the photograph, near the final turn of the new track. (Author's collection.)

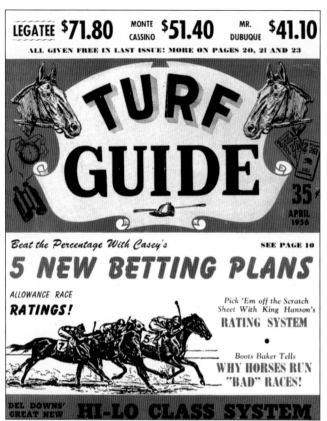

Turf Guide, the cover of which is shown here from April 1956, was a popular national publication that documented racing in the Windy City and throughout the United States during the 1950s and 1960s. It was a favorite among Chicago racing fans during those days, providing handicapping information and stories about individual horses, trainers, jockeys, and owners. (Author's collection.)

After a January 20, 1952, fire damaged Lincoln Field's grandstand, Thoroughbred races were shifted to Hawthorne until 1954. Because of its close proximity to Chicago, the Stickney oval continued to draw large crowds, necessitating the renovation of its grandstand and clubhouse. This photograph from 1957 shows Hawthorne after the new $1 million clubhouse had been updated, allowing for a seating capacity of 12,000. (Courtesy of Hawthorne Race Course.)

The voice of Chicago in the 1950s was none other than the immortal Stan Bergstein, seen here studying the field for the 1957 opening night featured event at Maywood Park. Bergstein later became one of the most recognized and well-respected journalists, publicists, and advocates of the sport of harness racing and today serves as executive vice president for Harness Tracks of America. (Author's collection.)

This photograph from 1957 catches a reflective Harry Burright sitting at the front of his barn, near the original barn built by Dr. Arthur Galt, on the Maywood Park backstretch. Harness horsemen typically train every morning and, after feeding their horses lunch, take some time to relax in the company of their animals. Later in the afternoon, they will start preparing the horses for the evening's races. (Author's collection.)

Driver Joe Lighthill accepts a trophy from sportswriter Jim Segretti after winning the $5,000 Chicago Harness Writer's Trot with Gladys Volo at Maywood Park on April 12, 1957. Segretti was a well-known horse racing writer, based in the Windy City, who covered both Standardbred and Thoroughbred racing for several newspapers. (Courtesy of Sportsman's Park.)

The Sportsman's Park clubhouse got a face-lift in this photograph from April 1, 1959. The opening of the 1959 Thoroughbred meet was slated for April 18, and painters ready the Laramie Avenue entrance. As well, inside the clubhouse a new dining room was added at a cost of $1.5 million. (Author's collection.)

Amboy, Minnesota, native Del Insko began competing at Chicago tracks in the 1950s. Born on July 10, 1931, Insko drove in his first race on July 4, 1946, just six days before his 15th birthday. As North America's leading driver in 1960, Insko won 156 races and was named Driver of the Year. Some of his top mounts included Speedy Rodney, Henry T. Adios, Overcall, Merrie Gesture, and Land Grant. (Author's collection.)

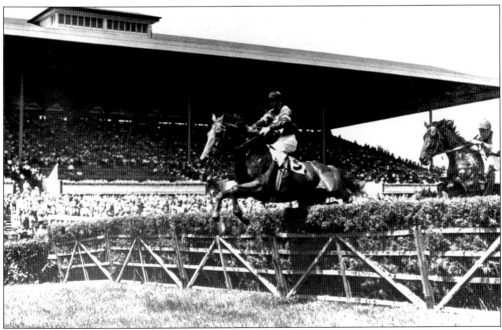

Steeplechasing was once a popular Chicago sport, held regularly at both Hawthorne Race Course and Arlington Park, but was phased out by the end of the 1950s. This photograph shows Hal Marbut, ridden by Crompton Smith, in one of the last steeplechase events ever held at Arlington Park, on June 4, 1958. (Author's collection.)

This Maywood Park program from April 22, 1959, features a 10-race card with six pacing events and four trotting races. Then, as today, more races for pacers are typically featured on a harness racing program than trotting events. Some of the drivers listed in this program included Tom Wilburn, Dormie Perrin, Elwood Magee, Glen Kidwell, Del Insko, Jacques Grenier, Carol Hukill, Jack Hankins, Connel Willis, and Don Busse. (Author's collection.)

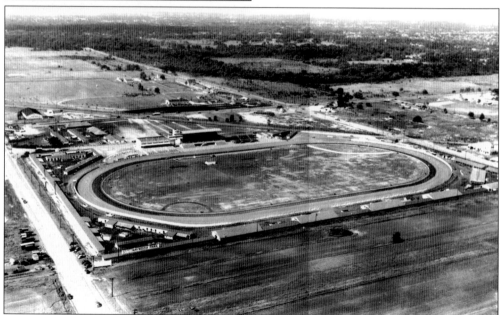

This aerial view of Maywood Park in 1959 provides an excellent view of the racetrack and surroundings, which have grown considerably since 1946. The barns are now located on the west, south, and east sides. There is also a small barn area behind the grandstand and clubhouse that today is the valet parking lot. On opening night, March 29, NBC's *The Tonight Show* provided live coverage of the evening's races. (Courtesy of Duke Johnston.)

This cover of the *Horseman and Fair World* magazine, from December 30, 1959, depicts Horseman of the Year Joe O'Brien. Known as "Gentleman Joe," O'Brien was a top trainer-driver in his day. The *Horseman*, as it is known in harness racing circles, is the oldest weekly publication in North America devoted exclusively to Standardbred racing, having been established in 1877. (Author's collection.)

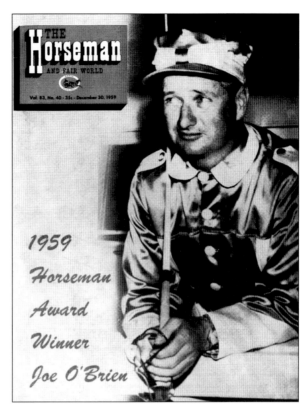

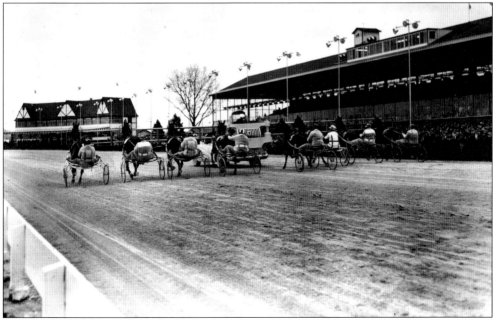

Aurora Downs reopened its doors on March 2, 1959, for a 72-day meeting on the newly rebuilt racing surface that also sported a half-mile training track. Here fans line up against the grandstand fence to watch as a field of eight pacers goes behind the starting gate. (Courtesy of the *Horseman and Fair World*.)

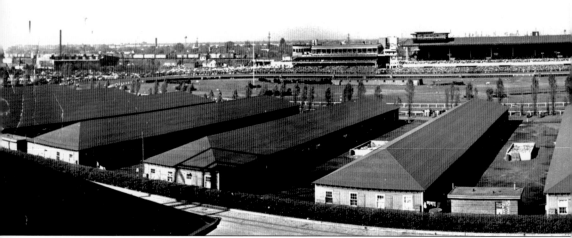

A view of Sportsman's Park in the late 1950s, after the track had been converted from a half-mile oval to a five-eighths-mile venue, is seen here. The barns were built in the classic shed-row design, and the small training track just beyond the final turn is clearly visible in this photograph, which was taken from the Hawthorne grandstand. During those years, Sportsman's had installed a closed-circuit television network within the facility and in 1958 resurfaced and regraded the

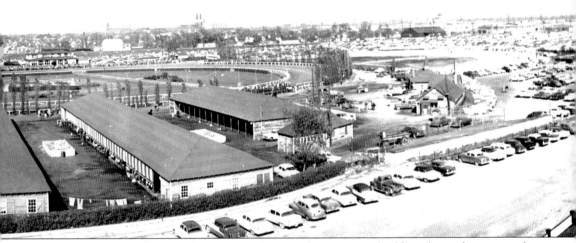

racetrack at a cost of $60,000. In 1959, the former administrative building, located just east of the grandstand, was revamped to include a jockey's room, racing secretary's office, paddock, and six-bed hospital. In 1960, the racetrack would spend another $1.5 million on a 860-seat dining room attached to the existing clubhouse, bringing the total spent on improvements from 1955 to $5 million. (Courtesy of Hawthorne Race Course.)

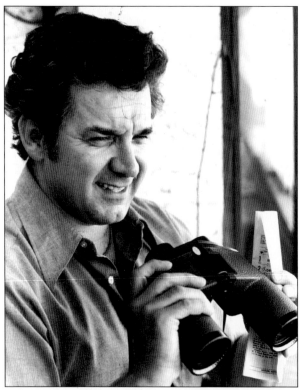

Phil Georgeff was the legendary racetrack announcer for Sportsman's Park, Arlington Park, and Hawthorne Race Course from 1959 to 1992, and over the years, he became well known for his famous mantra of "Here they come spinning out of the turn!" He would later be added to the *Guinness Book of World Records* for having called over 96,000 races during his announcing tenure. (Courtesy of Sportsman's Park.)

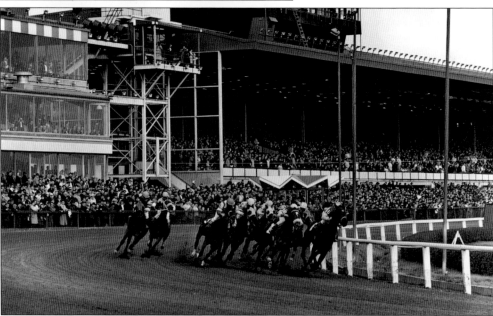

Sportsman's Park's grandstand and clubhouse were always packed with capacity crowds during the 1960s. Here thousands of spectators watch a field of Thoroughbreds rush around the tight first turn at Sportsman's Park. In 1963, Sportsman's Park recorded its first $1 million average handle, and it was also the first time that the $2 million handle plateau was reached and surpassed. (Courtesy of Sportsman's Park.)

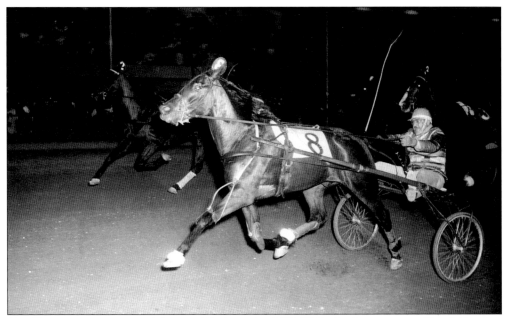

Gay Harvest scores a win at Maywood Park on April 27, 1961, for driver-trainer Chuck Rumley, who steered him to a 2:12 clocking. The equipment worn by Gay Harvest is typical of rigging found on trotters: knee boots and bell boots on his front legs, trotting boots on his hind legs, and an open bridle with a simple chin strap. (Author's collection.)

The Sportsman's Park's stands are readied by cleaners for the afternoon's races, while the racetrack is groomed in the distance by a grater, in preparation for the Thoroughbreds that will compete over its surface on April 15, 1960. Hawthorne Race Course's grandstand is visible in the background, on the right, just behind the Sportsman's Park tote board. (Courtesy of Sportsman's Park.)

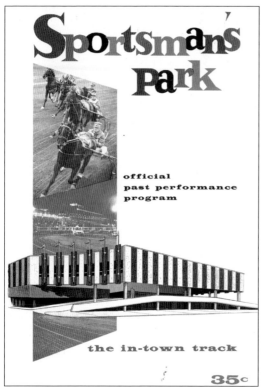

A Sportsman's Park harness racing program from August 9, 1960, features the $15,000 American National Stake for three-year-old trotters, with two divisions returning the same night for a final. The first heat was won by Star Performer in 2:02.4f with trainer Ralph Baldwin driving, while In Haste took the second heat for trainer-driver Stanley Dancer in 2:04.4f. In the final, In Haste prevailed in 2:03.1f. (Author's collection.)

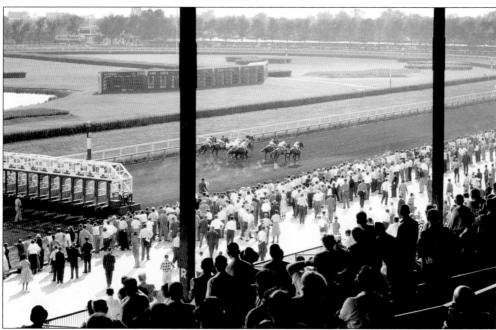

Thoroughbreds break from the gate at Hawthorne Race Course in 1960, as viewed from the grandstand. That year the mighty racehorse Kelso would grace the Stickney oval, claiming the revered Hawthorne Gold Cup, his first "hundred grander" victory, that helped to earn him the first of five consecutive Horse of the Year titles. (Courtesy of Hawthorne Race Course.)

Bill Hartack was the leading race-winning rider in the United States in 1955, 1956, 1957, and 1960, and the leading money-winning jockey in 1956 and 1957. A member of racing's hall of fame, Hartack was the first jockey to earn $3 million in a year. He won five Kentucky Derbies, three Preakness Stakes, and one Belmont Stakes and rode frequently in Chicago. Upon retirement, he became a Chicago Thoroughbred steward. (Author's collection.)

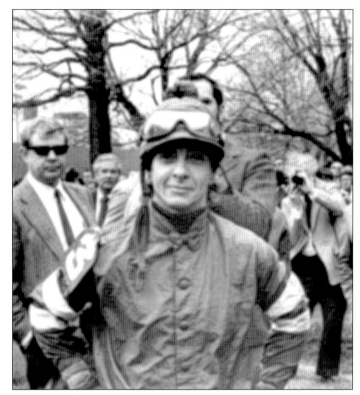

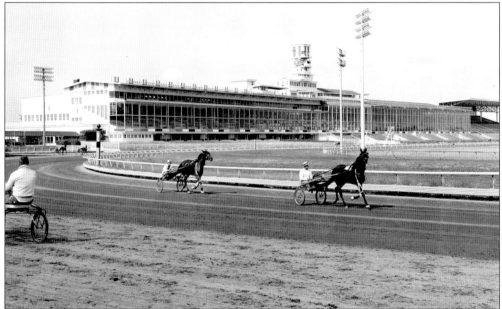

Standardbreds jog and train over Washington Park's one-mile oval on opening day, September 3, 1962, the first year harness racing was offered there. Managed by Marge Everett, the track boasted the largest opening-night crowd ever in harness racing, with 30,222 patrons attending. Eight years later, Everett admitted to bribing Illinois governor Otto Kerner in order to garner choice racing dates for Arlington and Washington Parks. (Courtesy of the *Horseman and Fair World*.)

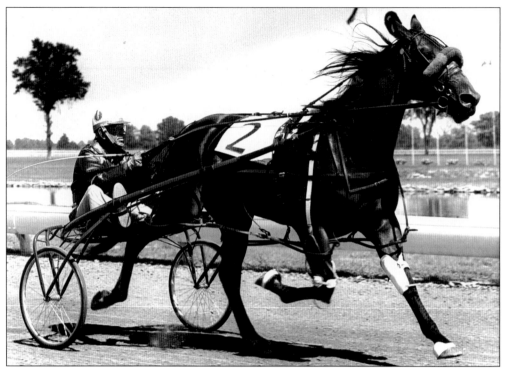

In 1964, a freshman pacing colt emerged named Bret Hanover. The robust son of Adios—Brenna Hanover—Tar Heel would pace to 24 wins that season, earning $173,298. Bred by the famed Hanover Shoe Farms of Pennsylvania, Bret Hanover earned $922,616 in his lifetime and become one of the most revered horses in harness racing, winning 62 of 68 career starts. Here "Big Bum" is steered by his trainer-driver Frank Ervin. (Author's collection.)

Maywood Park crew members check the backstretch lights as trotters and pacers jog around the half-mile oval seemingly unaffected one morning in the mid-1960s. Standardbreds are known for their quiet nature and tolerance for large equipment and other machinery. Once retired from racing, they make useful riding horses, excelling in both Western and English equestrian disciplines. (Courtesy of Maywood Park.)

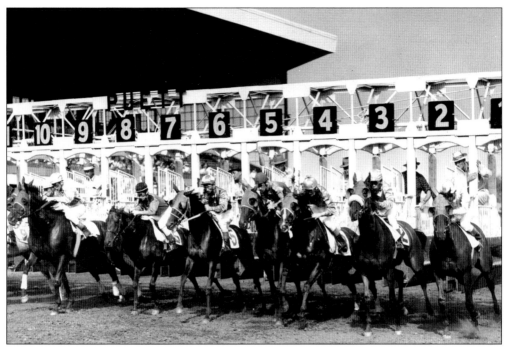

Thoroughbreds break from the modern electrical Puett starting gate at Hawthorne in 1964. The United Puett Starting Gate Corporation, out of Bellows Falls, Vermont, traces its roots back to the 1920s in Upstate New York. Its first gates were constructed out of angled iron and round tubing and were bolted together in sections so that they could be easily shipped. (Courtesy of Hawthorne Race Course.)

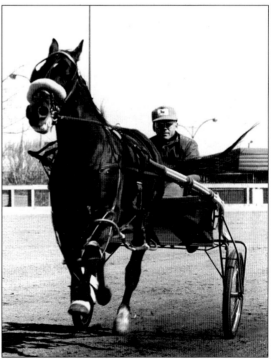

Henry T. Adios captured the $70,976 American National Maturity Pace at Sportsman's Park in 1962 for owners Dr. Nicholas and Angela Derrico of New York. The son of Adios—Greer Hanover—Nibble Hanover retired a world champion in 1964, holding three track records, and was the leading money-winning stallion regardless of gait with $705,198. Here he is being schooled by his trainer-driver Del Insko. (Author's collection.)

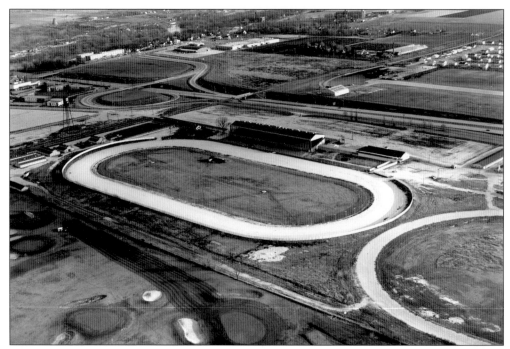

This photograph shows Aurora Downs in 1967, with the half-mile jogging track clearly visible at the right. Used as a training center for harness horses since 1951, Aurora survived two fires in 1955, although 13 Standardbreds perished in the second one. In the early 1960s, Aurora Downs also served as the temporary training headquarters of Sonny Liston, prior to his first fight with Floyd Patterson in 1962. (Courtesy of the *Horseman and Fair World*.)

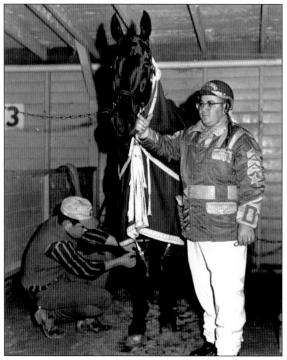

Jimmy's Pilot was named the Illinois Horse of the Year for 1965, 1966, and 1967. Trainer Delbert Insko holds Jimmy's Pilot by the halter in the Maywood Park paddock in 1966, while caretaker Dan Shetler adjusts his knee boots. The son of Knight Pilot—Sharon Lee Scott—Eddie Havens won $278,608 during his 11-year racing career, taking a mark of 1:57.4 as a five year old. (Author's collection.)

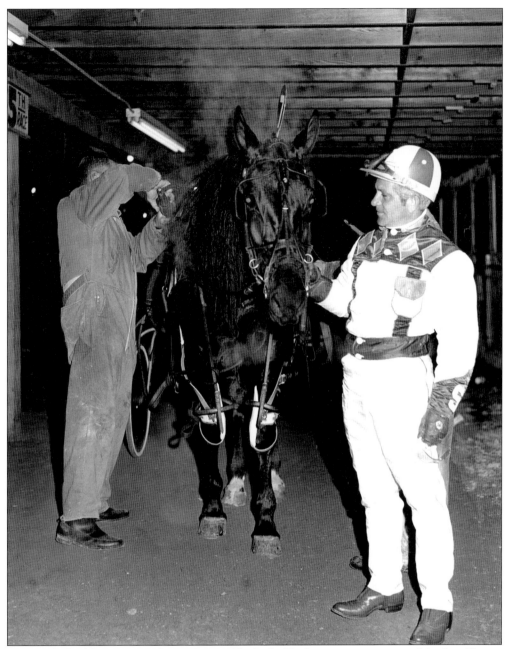

Veteran hall of fame trainer-driver George Sholty holds the great pacing mare Meadow Elva in the Sportsman's Park paddock in 1968, as she is hooked to her racing sulky by a caretaker. The daughter of Thorpe Hanover—Julia Frost—Adios, she was no stranger to the Chicago ovals during her career, which saw her earn $356,071 and score a mark of p,4,1:59.2h. (Courtesy of Sportsman's Park.)

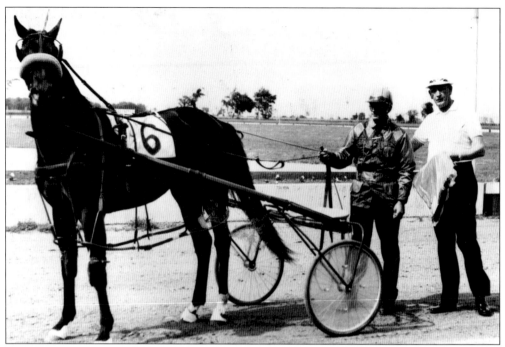

Active Don was one of the best pacers in Chicago in 1968. Here Orrin Baker presents a trophy to driver Glen Kidwell on June 2, 1968. Owned by Virginia Hensen, Active Don was the 1968 and 1969 Illinois Harness Horse of the Year. Both Active Don and Glen Kidwell—who won 1,120 races and over $3 million in earnings—are in the Illinois Harness Racing Hall of Fame. (Author's collection.)

Standardbreds jog over the half-mile oval at Aurora Downs in 1968, in a view from the infield, facing the ornately decorated grandstand. Eventually, in the 1980s, after operating as a training center for many years, Aurora Downs closed its doors for the final time and was sold to developer Zander Bowmann. (Courtesy of the *Horseman and Fair World*.)

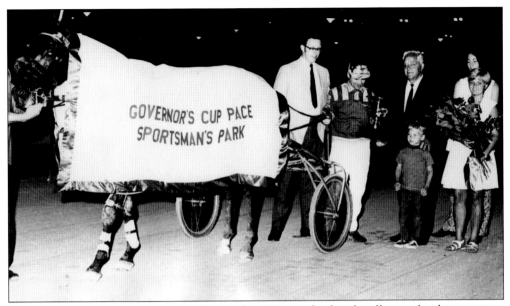

In 1969, the great racehorse Overcall paced to 22 straight free-for-all wins for driver-trainer Del Insko and owner Helen R. Buck. Phil Langley (left) and Insko celebrate in the Sportsman's Park winner's circle after Overcall romped to victory in 1:58 in the $25,000 Governor's Cup Pace on July 12, 1969, at the Cicero oval. Overcall was voted Pacer of the Year by virtue of his undefeated season. (Author's collection.)

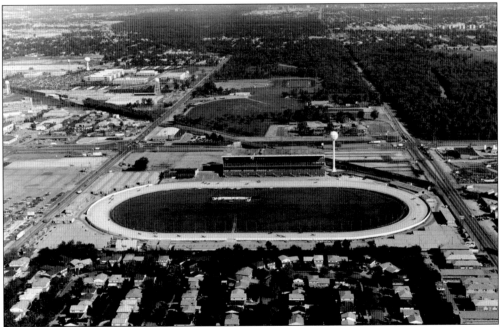

In 1969, Maywood Park began construction of 39 steel and concrete barns, containing 984 stalls, blacksmith shops, and nearly 200 living quarters for caretakers, and a modern paddock with attached driver's facilities. The area just to the west of the track is now home to a large shopping center, grocery store, and restaurants. Melrose Park, located south of Maywood's backstretch area, is still a thriving neighborhood today. (Author's collection.)

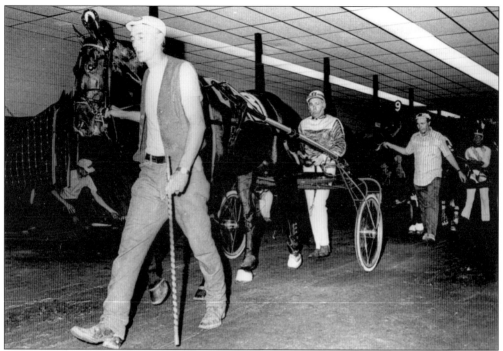

Caretaker Joe Wildman leads Nevele Pride out of the Sportsman's Park paddock on July 19, 1969, with hall of fame trainer-driver Stanley Dancer walking behind his star trotter. The event was the $70,394 American National Maturity Trot in which Nevele Pride eventually finished fourth to the winning Snow Speed. (Courtesy of Sportsman's Park.)

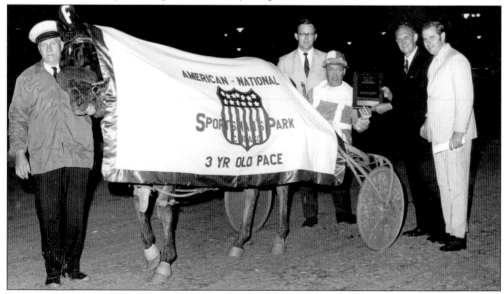

Dr. John Freed (second from right) of Terre Haute, Indiana, presents the winning trophy to driver-trainer Billy Haughton after Lavern Hanover captured the $25,000 American National Stake for three-year-old pacers at Sportsman's Park on June 14, 1969. Joining them in the winner's circle are a youthful Phil Langley (left), Sportsman's Park director of racing, and William H. Johnston Jr. (far right), president of Fox Valley Trotting Club. (Courtesy of Sportsman's Park.)

Four

NIGHT FEVER
THE 1970S

Beth Jozwiak, daughter of track superintendent Al Jozwiak, relaxes in the Sportsman's Park infield on May 30, 1970, along with a flock of ducks that called the racetrack home. In 1972, the National Jockey Club, owned by the Bidwell family, which ran Sportsman's Park, became the longest-running consecutive Thoroughbred meeting in history. The 1970s were also the beginning of three great decades of Standardbred racing at the Cicero oval. (Courtesy of Sportsman's Park.)

This Balmoral program from December 19, 1970, features a 10-race card and touts the facility as "America's Most Modern Harness Racing Plant." (Author's collection.)

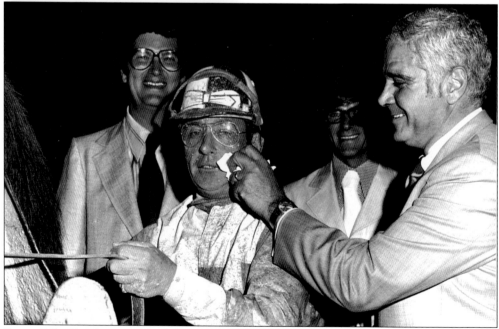

Driver Billy Haughton won both $20,000 divisions of the Maywood Pace—with Rum Customer and Carbine Hanover on July 23, 1970. Rum Customer won the Pacing Triple Crown en route to being named Pacer of the Year for Haughton that season. Here visiting Pocono Downs executives James and Edward Durkin (background) watch as Maywood Park executive vice president Sid Anton (right) wipes debris off Haughton's mud-stained goggles. (Author's collection.)

Walter Paisley was one of the most successful drivers ever in Chicago. Born on March 10, 1941, and nicknamed Butch, Paisley captured driving titles at every Chicago venue, including the Maywood Park title three times: in 1971 (51 wins), in 1979 (160 wins), and in 1983 (128 wins). In 1993, Paisley abruptly hung up his colors after winning 5,713 races and more than $34.6 million in purses. (Author's collection.)

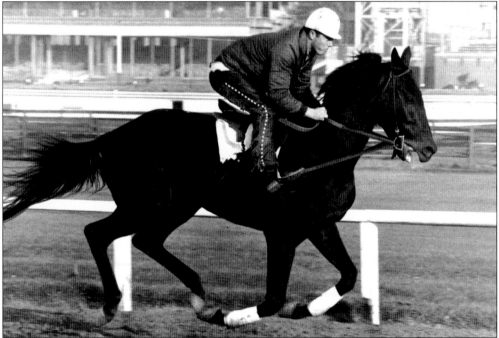

Terrible Tiger and exercise rider Jerry "Ace" McGrath work out at Sportsman's Park in preparation for the $25,000 Chicago Today Handicap on November 21, 1971, which he won. Terrible Tiger was one of the most traveled horses in the country and a winner of $263,313 and 23 starts in his career. His interesting pedigree included British, Irish, Italian, French, and American genes. (Author's collection.)

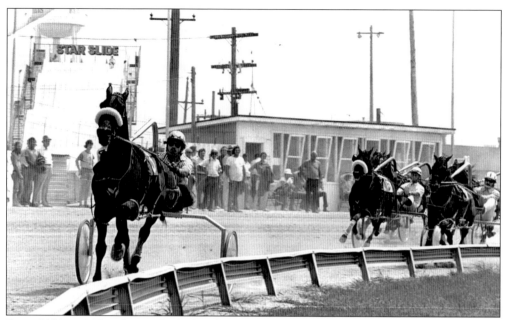

From 1971 to 1974, the single-shaft sulky appeared to be the wave of the future. However, safety issues soon overshadowed what appeared to be a speedy alternative to the traditional double-shafted race bike, and the single shaft was outlawed in 1975. Here top Windy City reinsman Ronnie "Boom Boom" Marsh leads a field of pacers around the final turn at Maywood Park in 1971. (Author's collection.)

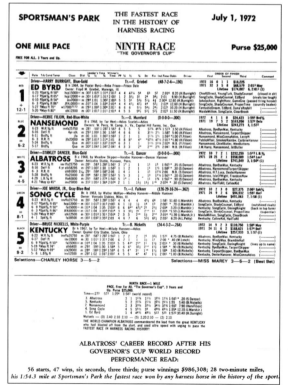

This Sportsman's Park program from Saturday, July 8, 1972, features a 10-race card with a post time of 8:30 p.m. and touts the upcoming stakes races and giveaways on its cover. The $25,000 ninth race Governor's Cup touted one of the finest fields of free-for-all pacers in Chicago history—with Ed Byrd, Nansemond, Song Cycle, Kentucky, and eventual winner Albatross pitted against one another. (Author's collection.)

In this photograph, Robb Ranger is hooked to a single-shaft sulky for driver Jim Curran, in a 1976 Washington Park victory. Race bikes, or sulkies, were traditionally attached to the horse via straps that wrapped around the sulky shafts, keeping the cart tight to the horse's body. Today's trotters and pacers utilize a quick-hitch harness attachment, which snaps the sulky quickly and securely into place via couplers. (Author's collection.)

Albatross works out at Sportsman's Park in 1972 with trainer-driver Stanley Dancer in the jog cart. This world champion would go on to earn $1,201,470 and take his career mark of 1:54.3f in the Governor's Cup at the Cicero oval before 18,000 enthusiastic fans—which was the fastest mile paced that year. (Author's collection.)

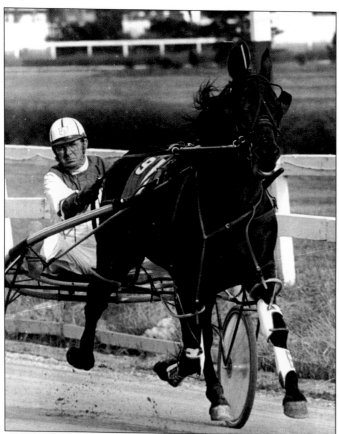

Sir Dalrae is put through his paces for trainer-driver Jim Dennis in preparation for his start in the 1973 U.S. Pacing Championship, which he won in 1:56f. That clocking was the fastest mile paced all season at Sportsman's Park. Sir Dalrae—a trotting-bred pacer—earned $678,314 in his career. He was versatile on all size tracks, and later that year, he set a Maywood Park record of 1:56.4h. (Author's collection.)

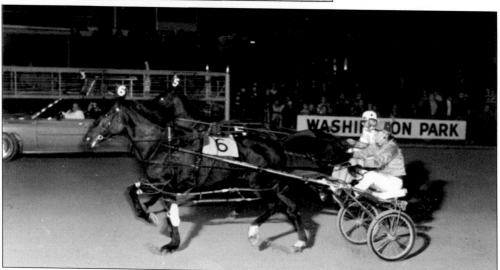

Sportsman's Park publicity director Mike Paradise bests *Chicago Tribune* writer Neil Milbert by a head on November 3, 1973, at Washington Park racetrack in the Sports Writer's Derby. Paradise was driving Grand Ace (6), an old mare from the Bob Farrington Stable. The sportswriters were steering their pacers in jog carts and zipped the mile in a 2:18 crawl, before a crowd of 5,176. (Courtesy of Mike Paradise.)

Secretariat, perhaps the greatest Thoroughbred of the 20th century, parades before the crowd on June 30, 1973, at Arlington Park. Regular rider Ron Turcotte is aboard the Triple Crown champion. Secretariat was showcased that day before an enthusiastic throng of Chicago fans, besting rivals My Gallant and Our Native in the one-and-a-quarter-mile Arlington Invitational. Secretariat won 16 of 21 career starts, earning $1,316,808. (Author's collection.)

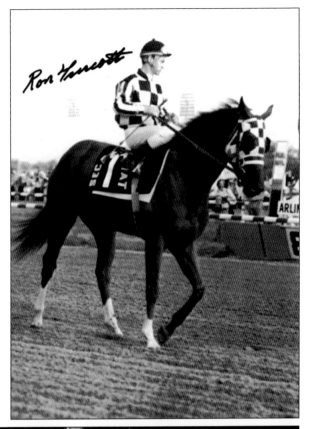

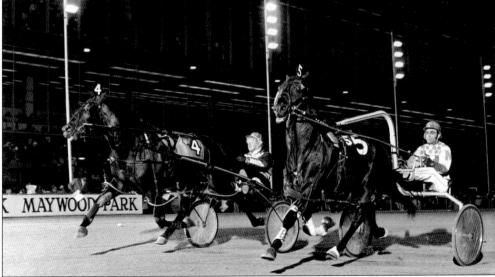

This photograph from 1974 at Maywood Park shows the pacers Sautree (4, with driver Harold Snodgrass) and Bret's Tune (5, with driver Joe Marsh Jr.) striding to the wire, as both have all four feet off the ground. Sautree is hooked to a traditional, double-shaft sulky, while Bret's Tune is harnessed to a single-shaft sulky, which would be outlawed by the United States Trotting Association one year later. (Author's collection.)

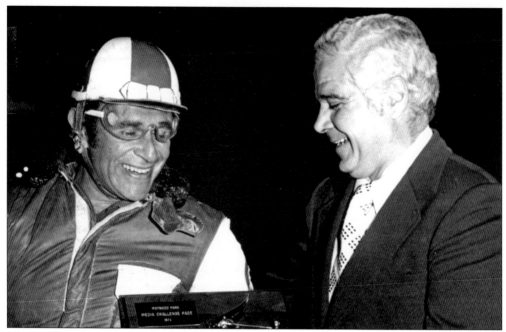

Maywood Park general manager Sid Anton presents the winning trophy to WBBM-TV newsman Bruce Roberts after he captured the Maywood Park Media Challenge Pace on May 9, 1974. Roberts faced rivals Mike Kiley and Neil Milbert of the *Chicago Tribune*, and Rick Tally and Mike Paradise of the defunct *Chicago Today*. Roberts was a huge horse racing fan and often reported from the Sportsman's Park Press Box. (Courtesy of Mike Paradise.)

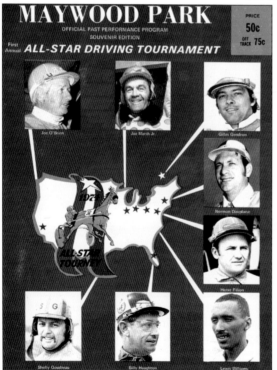

This program from May 22, 1974, features harness racing's top drivers competing in an all-star driving tournament at Maywood Park. The eight standout reinsmen include Billy Haughton, Lew Williams, Joe O'Brien, Shelly Goudreau, Joe Marsh Jr., Herve Fillion, Norman Deuplaise, and Gillies Gendron. These eight drivers piloted every horse in each of the 10 races on that night's card. (Author's collection.)

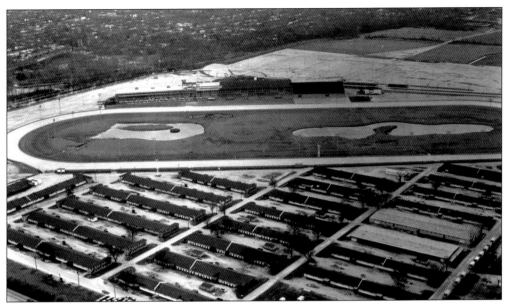

This view of Washington Park racetrack in 1974 shows the barn area. At the far end of each barn, on the left-hand side of this photograph, are two-story caretaker quarters for those grooms who preferred to supervise their horses on a 24-hour basis. Just behind the parking lot and the grandstand, the community of Homewood has overtaken the previously rural area. (Courtesy of the Homewood Historical Society.)

Walter Paisley steers his top pacer, Braidwood, around the Aurora Downs racetrack, just prior to qualifying the four-year-old son of Majestic Hanover—Petitpoint—Widower Creed in January 1974. The dark chestnut side-wheeler was one of the top horses ever to compete over Windy City ovals, earning $292,008 for the partnership of Paisley Enterprises and R. R. Roberto of Illinois. (Author's collection.)

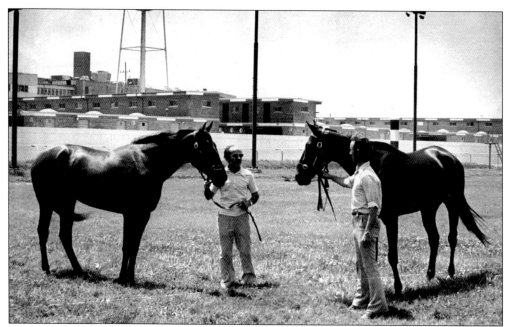

The filly Handle With Care (left) and the New Zealand–born gelding Young Quinn (right) share some fresh-air time in the Sportsman's Park infield in 1975. Young Quinn was one of the most successful horses to hail from Down Under and earned $752,597 with 32 wins. Handle With Care was one of the top pacing fillies of her time, winning numerous stakes throughout North America. (Courtesy of Sportsman's Park.)

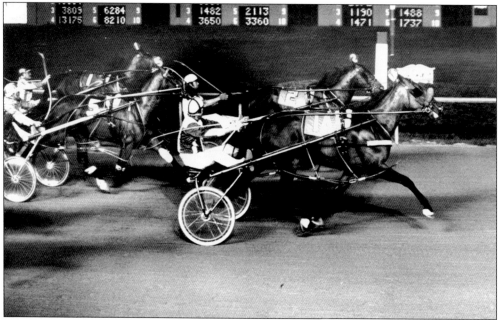

Handle With Care (1A) wins the $50,000 U.S. Pacing Series in 1:58 at Sportsman's Park on June 28, 1975, for driver Peter Haughton. That time was a record for a four-year-old pacing mare. Handle With Care went on to earn $809,689 in her career with 17 wins, 7 seconds, and 10 thirds from 58 career starts. (Courtesy of Sportsman's Park.)

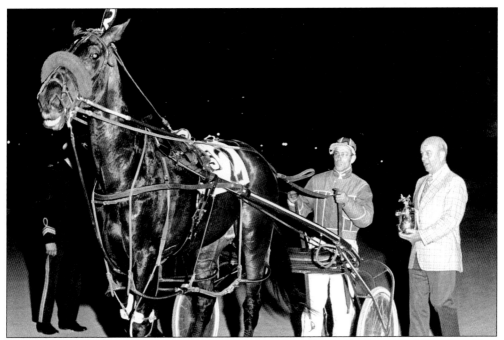

Arthur T. Galt presents a trophy to winning driver Jerry Graham, after he steered Smashing Don to victory in the 1975 Maywood Pacing Series. Smashing Don p,9,1:57 earned $504,532 in his career. (Author's collection.)

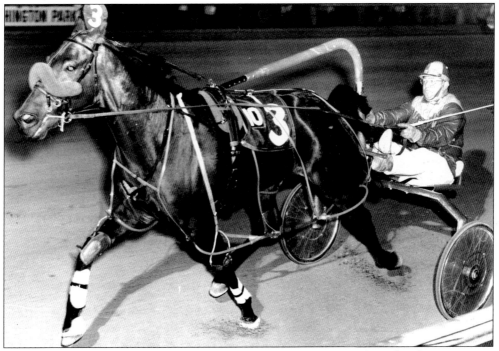

The $361,378 winner Jefferson wins at Washington Park in 1975 for Billy Shuter, wearing equipment traditionally worn by a pacer, including quarter, tendon, and knee boots on his front legs, pacing hobbles, and a large shadow roll on his bridle. (Author's collection.)

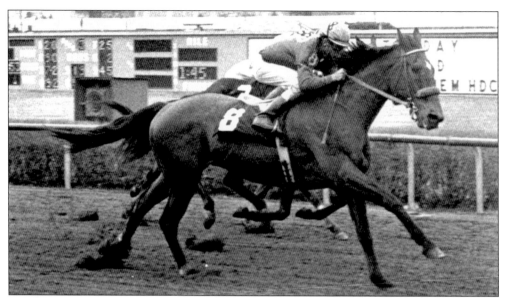

Maxwell G., or "Old Maxie," opened Sportsman's Park on March 15, 1976, winning by six lengths—as a 15 year old! Maxwell G. was the subject of countless national news columns and was the honored guest at Sportsman's Fan Appreciation Day on April 7, 1976. Born on April 30, 1961, he raced from 1965 through 1977, amassing 47 wins, 52 seconds, and 37 thirds and earning $181,420. He won at least one race every year of his 13-season career. (Author's collection.)

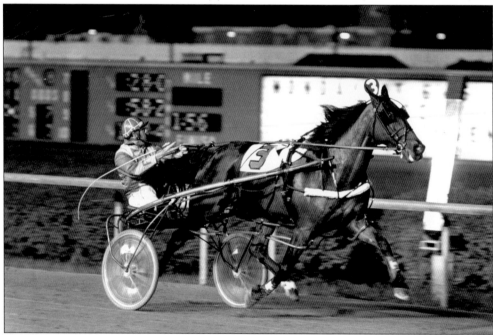

The "Horse That God Loved" was Rambling Willie, no stranger to the Sportsman's Park oval. Here Willie and trainer-driver Bob Farrington score his four-year-old record of 1:56.1f. During the season, he won 19 races and $264,405 in seasonal earnings. The gelded son of Rambling Fury—Meadow Belle raced 10 years, winning 111 races, with 55 seconds, and 41 thirds from 258 starts and $2,038,219 in career earnings. (Courtesy of Sportsman's Park.)

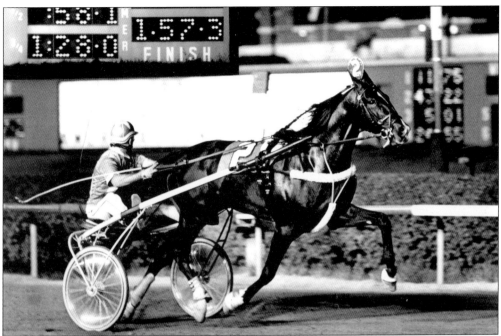

One of the most impressive performances of the decade came when Dream of Glory and trainer-driver Stan Bayless recorded a new track record clocking and personal best of 1:57.3f over Sportsman's Park new five-eighths-mile oval on August 21, 1976. In this photograph of the finish, Bayless stares at the timer as he passes under the finish wire with his star trotter. Dream of Glory, a son of Speedy Count—Dixie Valley—Harlan, earned $473,316 in his career. After the victory, Bayless stands with director of racing Phil Langley as the winning blanket is placed on Dream of Glory in front of the Sportsman's Park grandstand and clubhouse on that summer night. Bayless, who retired from driving and training in 1993, is now a handicapping consultant for the Indiana harness tracks. (Author's collection.)

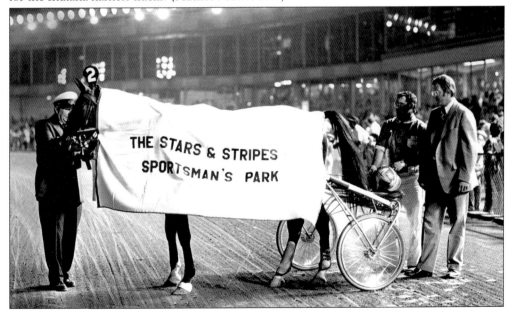

Mighty Oak Speed was a four-year-old trotter conditioned by trainer-driver Connel Willis to 1977 Illinois Trotter of the Year honors. That season the son of Pronto Hall earned $62,970 from eight wins, six seconds, and a trio of thirds from 20 trips postward. The gelding took his career mark on September 2, 1977, at Sportsman's Park with Willis in the sulky, trotting in 2:01.f around the five-eighths-mile oval. (Author's collection.)

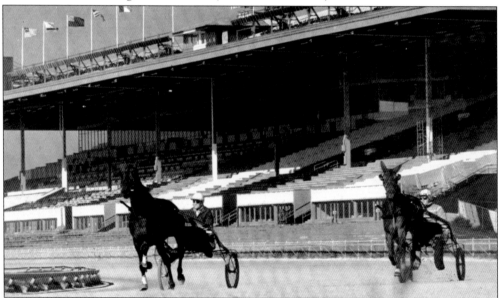

When the meets shifted from the Thoroughbreds to the Standardbreds, it was a busy time for the racetrack maintenance crew. A harness racing surface does not require as much cushion and is much harder than the softer footing that Thoroughbreds race on. Arlington Park held two consecutive harness meetings—in 1977 and 1978. This photograph shows a pacer and trotter with their trainers at Arlington Park in 1977. (Author's collection.)

This is a view of Maywood Park's grandstand from the infield, facing the grandstand and clubhouse just prior to the evening's races. Maywood Park had been purchased by the Johnston family in 1977, with William Johnston II at the helm and his sons William "Duke" Johnston III and Johnny Johnston assisting. (Author's collection.)

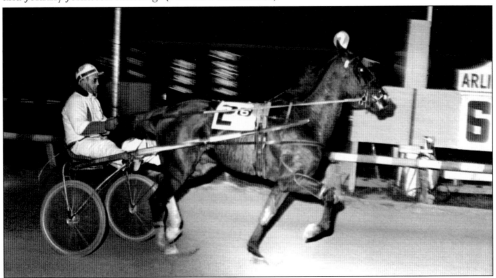

Stanley Banks steers the trotter Hickernut to victory at Arlington Park in 1977. Banks was a top driver on the Illinois circuit for many years and along with brothers Lester and Dwight established one of the many harness families that competed with and against each other on a nightly basis. Stanley retired from driving in 1996 at age 60 with 3,513 wins and $17,167,654 in career earnings. (Courtesy of Sportsman's Park.)

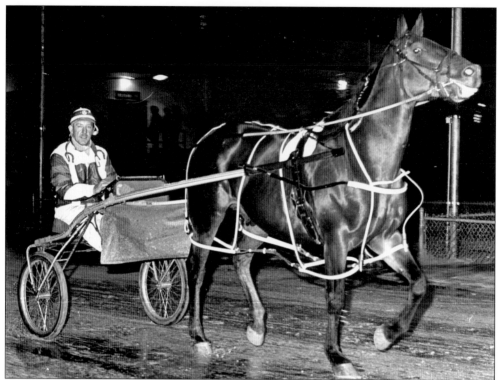

Taurus Bomber—one of the finest Illinois-bred pacers ever—parades at Maywood Park in 1979 with trainer-driver Connell Willis at the controls. Taurus Bomber earned $451,356 under Willis's tutelage, with 40 wins, 22 seconds, and 12 thirds from 111 lifetime starts. He raced through his nine-year-old season, and took a top mark of 1:54.3 at age five. (Author's collection.)

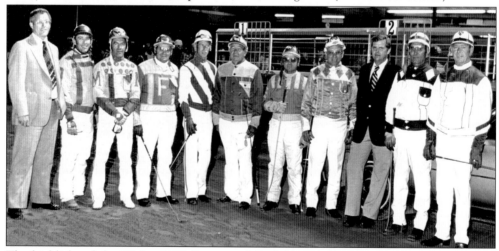

The highlight of the 96-day 1979 Sportsman's Park harness meeting was the tournament of champions that featured the sport's finest drivers, including, from left to right, Daryl Busse, Joe Marsh Jr., Bob Farrington, Walter Paisley, Harry Burright, Del Insko, Howard Beissinger, Dwayne Pletcher, and Jim Dennis. Sportsman's Park president Billy Johnston (third from right) and director of racing Phil Langley (far left) join the drivers in the winner's circle. (Courtesy of Sportsman's Park.)

In the mid-1970s, a new face emerged on the Chicago racing scene—a young man from Green Bay, Wisconsin, named Dave Magee, whose name would soon become synonymous with Windy City harness racing. Born on December 4, 1953, Magee grew up in a harness racing family and began traveling to the county fairs as a young boy, where he developed a long-lasting love for the sport of harness racing. Magee's red, white, and black colors have been a familiar sight in Chicago harness racing and throughout many tracks in North America since then. He has won titles at every Chicago track, including Maywood, Balmoral, Sportsman's Park, and Suburban Downs, and has scored $1 million or better earnings per season every year since 1979. Since 1986, the horses Magee has driven have earned $2 million or more each year. As of January 1, 2009, Magee has steered over 11,000 winners to $90.2 million in career earnings. (Author's collection.)

Starter Gene Montgomery (left) and assistant starter Nick Collini stand in front of their starting gate at Arlington Park in 1978. Standardbreds follow this car that increases its speed as it nears the starting line. Drivers put their horses' noses on the numbers located on the gate's wings that correspond to their assigned post positions. When the starter says "go," the horses are traveling about 35 miles per hour. (Author's collection.)

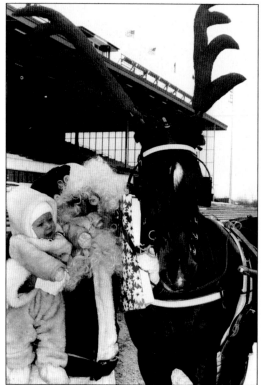

Santa is no stranger to the racetrack, as evidenced in this photograph of a good-natured trotter adorned with a pair of antlers during a promotion at Arlington Park in the winter of 1978. Marge Everett sold Arlington Park to Madison Square Garden Corporation, which later sold it to Richard Duchossois in 1983. (Author's collection.)

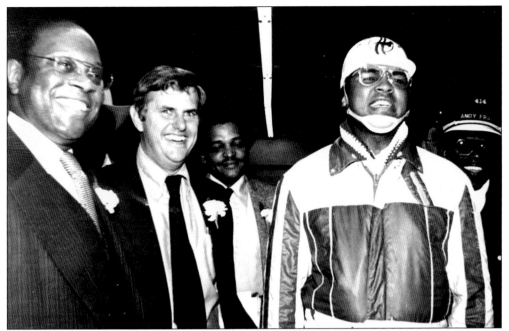

"The Greatest" Muhammad Ali, the 1979 world heavyweight boxing champion, smiles after wining an exhibition race at Maywood Park. Ali was on hand to raise money for the Provident Hospital of Chicago, at the time the oldest and largest African American managed hospital in Illinois. Ali is joined by Associates Racing president Lester McKeever (left) and Maywood Park president Billy Johnston (center) in the Maywood racing paddock. (Courtesy of Mike Paradise.)

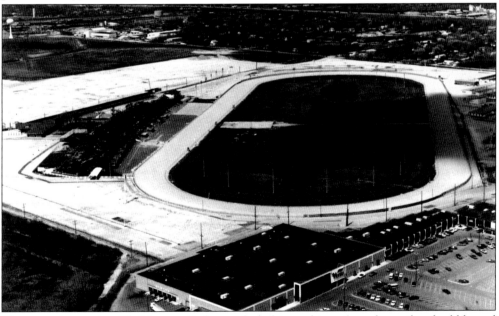

The once impressive Washington Park grandstand is nothing more than pile of rubble and ashes after a devastating fire obliterated the facility on February 5, 1978, as evidenced in this photograph. After the fire, Marge Everett sold the facility to developers who revamped the site for commercial and residential use. (Courtesy of the Homewood Historical Society.)

Joe Marsh Jr. accepts a trophy from owner Lloyd Arnold (left) after winning a race at Maywood Park in 1979. Marsh, a native of Curtice, Ohio, was one of the most respected and tough drivers on the East Coast and nationally before returning to Chicago in the 1990s. Marsh's five-decade career saw him guide 5,882 Standardbreds to $36,401,271 in career purse earnings. (Courtesy of Mike Paradise.)

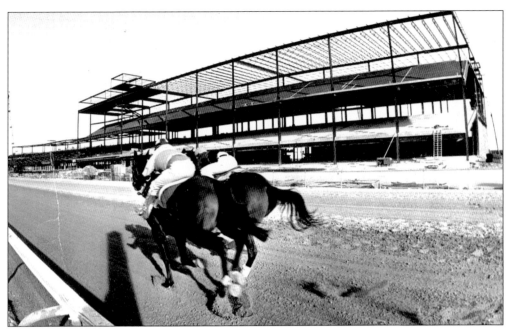

Two Thoroughbreds work out over the "old" Hawthorne racing strip on September 22, 1979, only a few days prior to the opening of the 75-day fall meeting. The "new" Hawthorne was a multimillion-dollar structure that was steadily approaching its early 1980 completion date, restoring the historic facility that was destroyed by fire on November 19, 1978. (Courtesy of Hawthorne Race Course.)

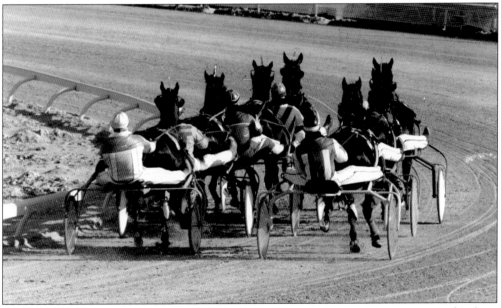

A group of pacers, as seen from the back, head double-decked around Sportsman's Park's sharp clubhouse turn that butted up against Laramie Avenue in 1979. Walter Paisley leads on the rail, followed by Carl Porcelli, Darryl Busse, and Don Brooks. The first two drivers on the outside are not visible, but the trailing horse—third on the outside—is being driven by Lavern Hostetler. (Author's collection.)

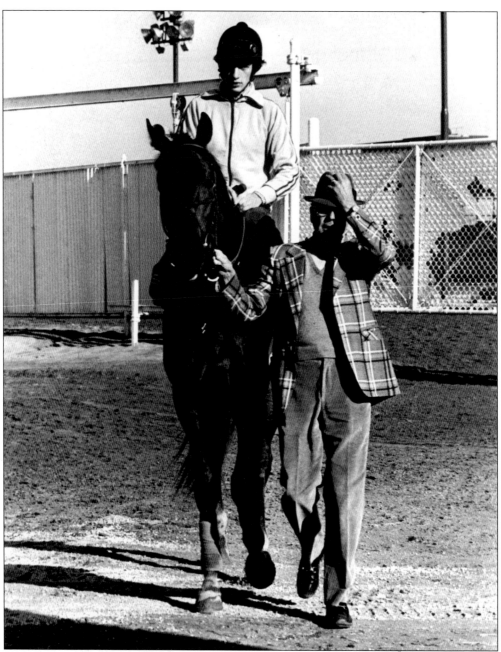

Ryehill Farm's Smarten, with exercise rider Philip Gleaves in the irons, is led to the track at Sportsman's Park by hall of fame trainer Woody Stephens in the spring of 1979. The dark bay son of Cyane was set to gallop in a workout in preparation for the $150,000 Illinois Derby. The colt found the Cicero oval to his liking, as he captured the Illinois Derby a few days later. (Courtesy of Sportsman's Park.)

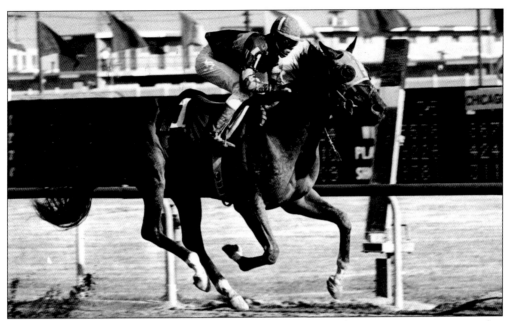

This photograph shows Smarten winning the 1979 Illinois Derby. Smarten won seven stakes that summer, including the Pennsylvania and American Derbys, and still holds the one-and-one-eighth-mile track record at Thistledown he set while winning the Grade II Ohio Derby in 1:47.4. Smarten earned $716,426 over two seasons and then retired to Maryland, where he began a 19-year-old stud career that saw him produce 600 foals. (Courtesy of Sportsman's Park.)

Hawthorne's winter harness racing meeting during the 1980s and 1990s included double-header programs, racing afternoon and evening programs. Typically the Stickney one-miler opened on New Year's Day. Here a masked driver provides a greeting to fans, while his trusty steed waits patiently. This photograph shows an unusual hood worn by this pacer, with a normal (facing forward) eyecup on the right and a backward-placed cup on the left. (Author's collection.)

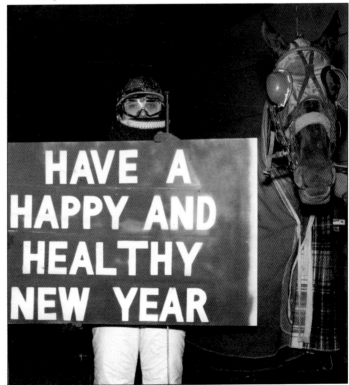

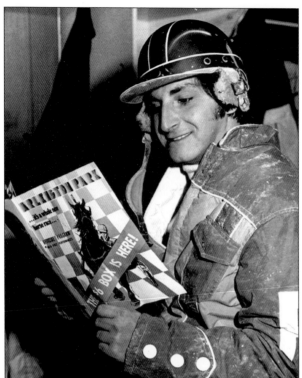

Clad in his winter racing silks and helmet, trainer Carl Porcelli studies the Arlington Park program before heading out into the cold in 1978. During his driving career, the Oak Park-born-and-raised Porcelli captured 1,005 races for earnings of $5,464,146. He has remained active on the Chicago circuit as a successful trainer and has conditioned over 1,500 winners to over $9 million in purses. (Author's collection.)

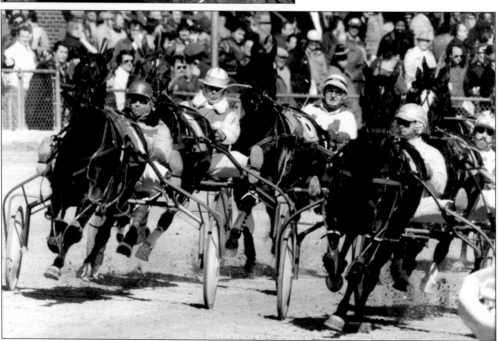

A field of pacers charges into the first turn at Maywood Park during a chilly Saturday afternoon program. Leading the herd, from left to right, are Daryl Busse, Don Brooks, Stan Banks, Jim Curran, and Terry Leonard. This was one of the few times that Maywood raced an afternoon program in the 1970s. (Author's collection.)

Five

MILLION-DOLLAR BABIES
THE 1980S

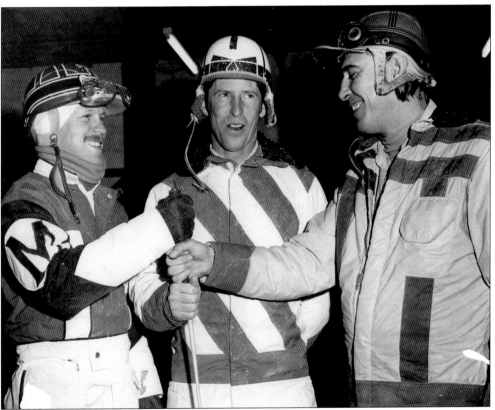

Three of the Windy City's most successful drivers share a laugh while in the Maywood Park driver's room. Dave Magee (left), Walter Paisley (center), and Daryl Busse (right) were all nightly competitors over Chicago's harness racing ovals during the 1980s. As well, this decade would usher in a new era for Arlington Park, which established racing's first-ever $1 million race. (Author's collection.)

Gil Levine became the voice of Sportsman's Park and summertime harness racing after former Windy City harness-racing announcer Stan Bergstein left Chicago. Levine's announcing spanned four decades, from the 1960s to 1997, the most successful years of harness racing in the Windy City. Levine's unique announcing style has yet to be rivaled. (Author's collection.)

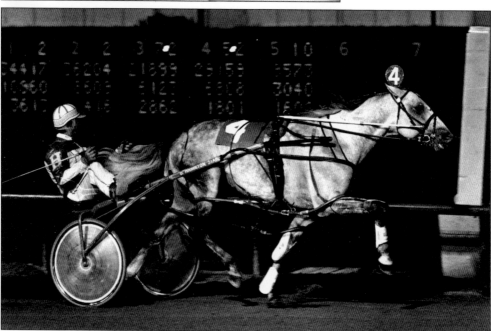

Always gritty and determined, the striking gray pacer Baron Lancer was another Sportsman's Park legend, winning here on May 16, 1980, at age six for driver Doug Hamilton in 2:00.1. The son of Baron Hanover would go on to amass $391,172 in his career from 40 wins, 34 seconds, and 36 thirds in 199 career starts. (Author's collection.)

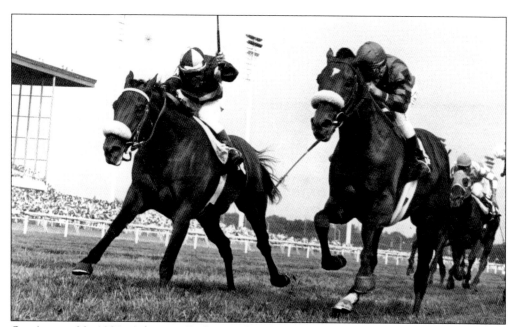

On August 30, 1981, Arlington Park introduced the Arlington Million, the first $1 million Thoroughbred race. The Bart was bested by rival John Henry, ridden by Bill Shoemaker (left), by a whisker on the turf. John Henry was Horse of the Year in 1981 and 1984, the year he captured the Arlington Million for a second time. John Henry retired in 1985 after earning $6,591,860, with a 39-15-9 record from 83 starts. (Courtesy of Joan Colby.)

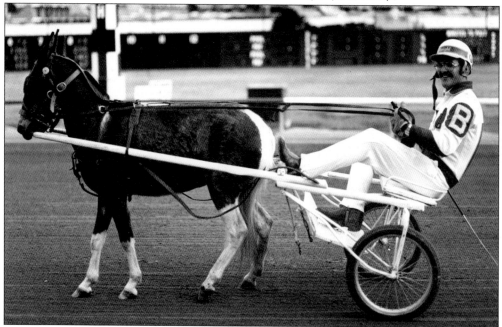

There was no shortage of fun at Sportsman's Park during the summer's harness racing meetings in the 1980s, as, along with concerts and giveaways, the track presented a variety of contests involving its most popular horsemen, to the delight of fans. Here driver Dwight Banks attempts to maneuver a donkey through the stretch at the Cicero oval. (Author's collection.)

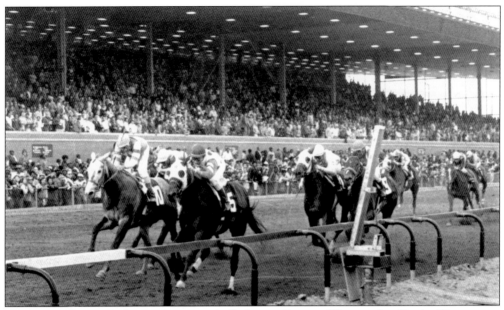

The 1981 Illinois Derby at Sportsman's Park saw Paristo (5) win the Grade III event, a nine-furlong test timed in 1:49.3. Pass the Tab (10) was second. Paristo finished third in the Preakness Stakes to Pleasant Colony one month later and retired with $212,541 in earnings. The 1981 Illinois Derby field also included 1981 Belmont Stakes winner Summing. (Courtesy of Sportsman's Park.)

Desperate Lady was one of Chicago's top pacing mares of the 1980s. The daughter of Rorty Hanover—Desperate Woman—Overtrick earned $387,707, with 40 wins from 77 starts. Desperate Lady scored her best season in 1983, when she won 26 races and $273,240 in seasonal purse monies, taking a career mark of p,3,1:54.1m. Here trainer-driver Joel Smith steers her to victory for owners Kathleen Baker and Maria Delacruz of Illinois. (Author's collection.)

Stanley Dancer jogs Dancer's Crown at Sportsman's Park in 1982. The two-year-old colt earned $406,512 that year and was the early choice to win the 1983 Hambletonian, but died before the race. Dancer often said that Dancer's Crown was the finest trotter he ever trained. (Author's collection.)

Jockey Oscar Sanches clings to the neck of the filly Jacquelyn E after she became fractious in the starting gate at Sportsman's Park on March 16, 1982. The gate crew is essential in assisting jockeys with their mounts in the moments before the starter says "go." Being a member of the starting gate crew is a dangerous job requiring common-sense thinking, a calm demeanor, and quick reflexes. (Author's collection.)

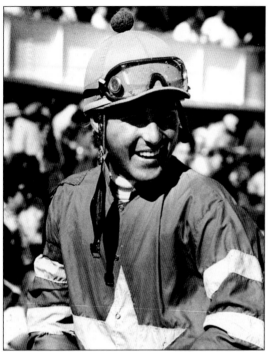

In 1982, jockey Randy "Ragin' Cajun" Romero set an Arlington Park record with 181 wins for the season. Romero began riding in 1975, winning 4,285 races in his career. He incurred over 20 racing-related injuries, but always rebounded. In 1983, he received burns to over two-thirds of his body from a freak sauna fire accident. After seven months of rehabilitation, Romero recovered, riding the top colt Personal Ensign and Breeders' Cup winner Go for Wand. Romero was aboard Go for Wand when she broke down in the 1990 Breeders' Cup Distaff race and had to be euthanized. Romero broke his pelvis and ribs as well in that accident. Eventually, due to his multiple injuries, Romero was forced to retire in July 1999. (Author's collection.)

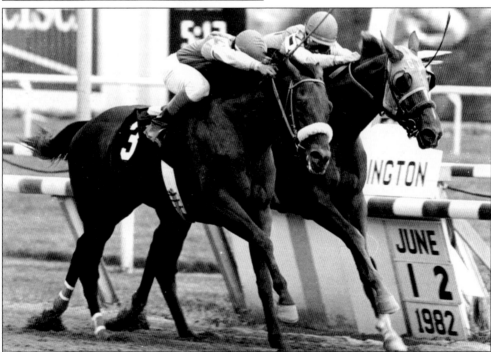

Wolfie's Rascal (3) prevails by a nose over Drop Your Drawers (10) in a nail-biting finish in the Arlington Classic at Arlington Park on June 12, 1982. Wolfie's Rascal would go on to become a top Illinois stallion. That same year, Arlington set three records: the largest single-race mutuel pool of $964,350, the largest single-race straight mutuel pool of $719,332, and the largest single Perfecta pool of $245,028. (Courtesy of Joan Colby.)

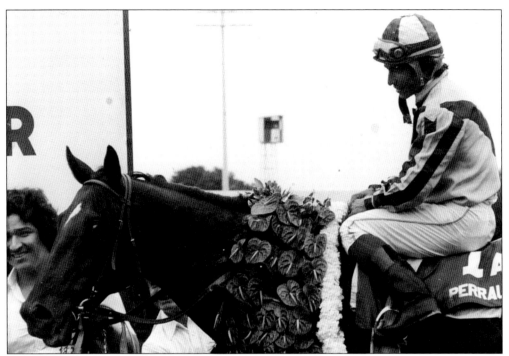

Jockey Laffit Pincay Jr. captured the 1982 Arlington Million aboard Perrault in a stakes record time of 1:58.4. The Panama native began riding in 1966, winning four Eclipse Awards and the leading U.S. jockey title seven times. A National Museum of Racing and Hall of Fame member, Pincay won the 1984 Kentucky Derby with Swale and three consecutive Belmonts from 1982 to 1984. He retired in 2002 with 9,530 winners. (Author's collection.)

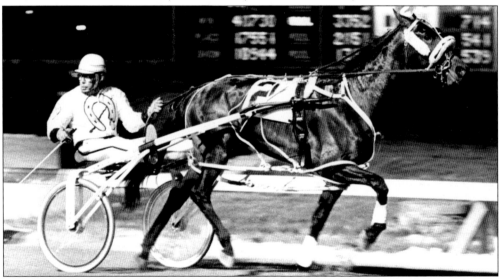

Carl Allen glances back as he guides his Carl's Bird to victory in the $262,000 Windy City Pace on May 18, 1984. The son of Sundance Skipper—Silent Katy—Silent Majority posted a 1:56.3h clocking for the one-mile test. The $131,000 winner's share of the purse made Carl's Bird harness racing's newest millionaire at the time. The bay stallion eventually retired with $1,180,292 in career earnings. (Author's collection.)

Hall of famer John Campbell steered both winners of the only two Breeders Crowns ever contested over Chicago ovals. In 1984, he drove Amneris to win the $555,000 Breeders Crown Two-Year-Old Filly Pace in 1:57.1h, and in 1985, he piloted Sandy Bowl to win the $354,553 Breeders Crown Aged Trot at Sportsman's Park in 1:56.3f. Here Campbell celebrates with Tom Charters, president of the Breeders Crown. (Courtesy of the Breeders Crown.)

Hall of famer Stanley Dancer relaxes atop the paddock at Sportsman's Park during the 1985 summer harness racing meeting, which hosted over 600 two-minute miles punctuated for the first time ever in Chicago history at the Cicero oval. As well, 13 track records were either broken or tied that season. (Courtesy of Mike Paradise.)

Mr. Dalrae and driver Dave Magee warm up on August 24, 1985, prior to taking a career mark at Sportsman's Park of 1:55.1f. The venerable son of Meadow Skipper—Queen's Crown—Queen's Adios earned $1,150,807 during his career, which spanned from 1981 through 1985. Mr. Dalrae was the younger half brother to his sibling Sir Dalrae, 10 years his senior. (Courtesy of Sportsman's Park.)

Owner-trainer-driver Mike Borys steers Hothead to victory at Maywood Park. As one of the top free-for-all pacers in Chicago in the 1980s, Hothead was a favorite with the fans. The son of B. S. Skipper—Two Step—Worthy Boy began racing in 1984 at age two, and he raced until age nine, earning $904,333 from 57 wins in his career for the Centaur Stables of Oak Lawn. (Author's collection.)

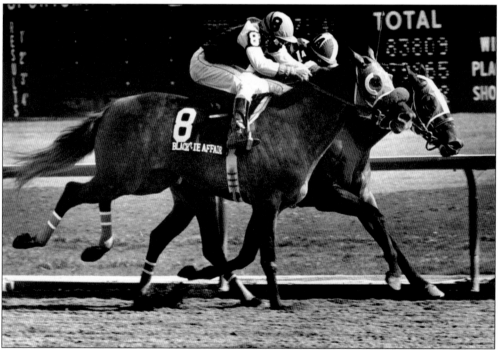

Black Tie Affair (8), with Eusebio Razo Jr. up, scores a nose decision over Nooo Problem (1A) and jockey Juvenal Diaz in the $54,400 Bold Favorite Handicap at Sportsman's Park on April 23, 1988. Ernie Poulos trained the son of Miswaki for Illinois owner Jeff Sullivan. The gray colt earned $3,370,694 lifetime and won the Grade I Breeders' Cup Classic in 1991, besting Kentucky Derby winner Unbridled in 2:02.95. (Courtesy of Sportsman's Park.)

On September 13, 1989, Pat Day set a North American record by winning eight of his nine mounts at Arlington Park. A four-time Eclipse Award winner, Day has 12 Breeders' Cup wins and a Kentucky Derby (1992 on Lil E. Tee) victory. The National Museum of Racing and Hall of Fame member (inducted in 1991) retired on August 3, 2005, after 32 years with 8,804 winners and $298 million in purses. (Author's collection.)

After unseating his driver, the pacer Loto King had a grand time at Maywood Park on March 25, 1986, pacing around the half-mile oval countless times until he was eventually caught. Age seven at the time, Loto King was no worse for the wear and continued to race through his 10-year-old season, retiring with $130,928 in earnings from 37 victories in 238 career starts. (Author's collection.)

Driver Dave Magee was voted into the Illinois Harness Racing Hall of Fame in 1987, winning an unprecedented 11 driving titles at the now-defunct Sportsman's Park, scoring those seasonal victories in 1981, 1982, 1983, 1986, 1987, 1989, 1991, 1992, 1993, 1994, and 1997. Here he guides the great trotter Brandenburg en route to winning an Illinois Standardbred Owners and Breeders Association Trot in 2:02.4 on June 30, 1986, at Maywood Park. (Author's collection.)

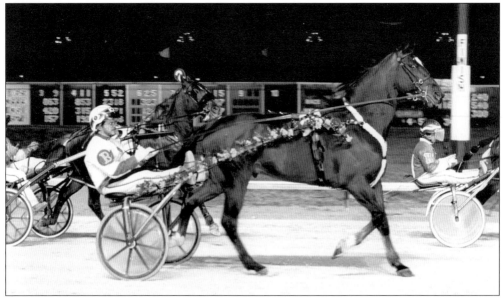

Egyptian Cheetah was a tough, Illinois-bred pacer who raced from ages 2 through 10 on the Windy City circuit, earning $509,789 for his trainer-driver Dwight Banks. Here the son of Egyptian Dancer—Kitty S.—Quick Reward is paraded before the Maywood Park grandstand for the last time, on March 19, 1988, with Banks in the sulky. Cheetah was owned by Illinoisans Rudy Langer, Edna Dempsey, and Norman Loevy. (Author's collection.)

Six

TURBULENT TRANSITIONS
THE 1990S

The racing sulky has continued to evolve through the decades, and the 1990s were no exception. In this 1992 photograph from Maywood Park, the pacer Taken by Surprise is hooked to a metal humpbacked sulky for driver Mark Saporito. These metal underslung race bikes were thin and lightweight, while the wooden versions were slightly heavier with a less distinctive bend at the horse's hindquarters. (Author's collection.)

The robust pacer Dirty Deeds is en route to victory, on October 13, 1990, at Maywood Park. Driver-trainer Dale Hiteman is at the lines behind the son of Egyptian Dancer—Taurus Time— Right Time, who earned $468,906 for Illinois owners Dtm Stable, Irwin Kay, R&D Samson Stables, and the Stanley Williams Estate. Dirty Deeds raced for seven straight years, procuring 45 wins with a record of p,7,1:54.f. (Courtesy of Maywood Park.)

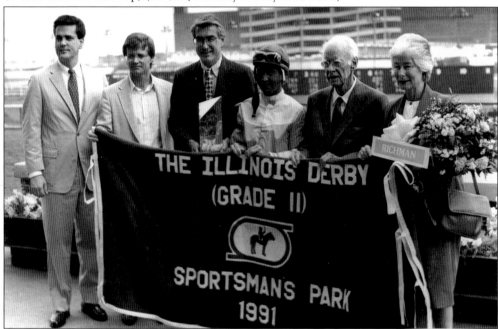

The winning connections of $532,000 Illinois Derby winner Richman stand in the Sportsman's Park winner's circle on May 8, 1991, after the 36th running of the Grade II stake. Celebrating, from left to right, are National Jockey Club owner Charles Bidwell III, trainer Bill Mott, Illinois governor Jim Edgar, jockey Jerry Bailey, and owners Mr. and Mrs. William F. Lucas. Richman earned $1,314,360 from 14 career victories. (Courtesy of Sportsman's Park.)

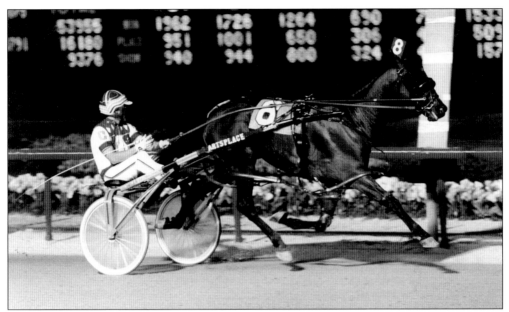

Artsplace captured the $345,200 American National for sophomore pacers at Sportsman's Park on June 29, 1991, for driver John Campbell and trainer Gene Riegle in 1:53.2. The son of Abercrombie—Miss Elvira retired with $3,085,083 in earnings and a mark of p,4,1:49.2. Owned by his breeders, Chicago-based George Segal and Brian Monieson, Artsplace became a top sire, with his foals earning over $130 million. (Author's collection.)

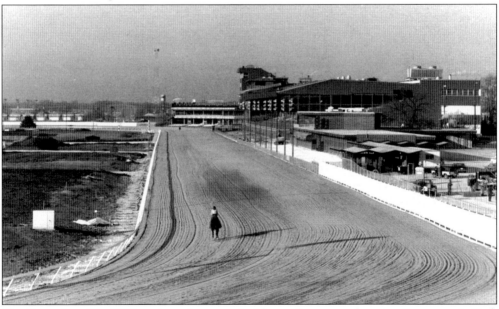

On December 19, 1991, a lone horse and rider gallop over the new Sportsman's Park seven-eighths-mile oval. The front and backstretch were lengthened to 1,436 feet, the existing clubhouse turn was reconstructed, and a new grandstand turn was built, using space-age geometrics. Work began in the summer of 1991 and was completed by mid-December. Costs for the track extension, including a new infield pond, totaled $3.6 million. (Courtesy of Sportsman's Park.)

Following the retirement of longtime Chicago Thoroughbred announcer Phil Georgeff, a young Kurt Becker took over the helm at Sportsman's Park for the 1993 Thoroughbred meeting. Becker would go on to call races at Arlington Park and Hawthorne, replaced in later years by Peter Galassi at Hawthorne and Sportsman's and by John Dooley at Arlington. (Author's collection.)

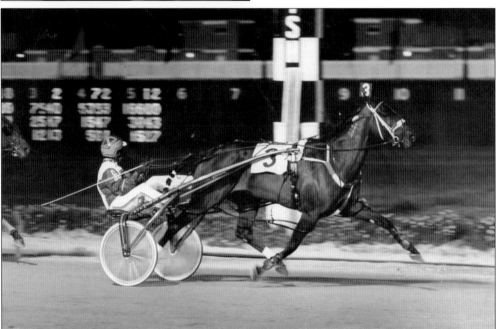

Pacific Flight N was one of the top pacing mares on the Chicago circuit in the mid-1990s, amassing $435,095 for the Illinois-based partnership of Jean Keifer, Bill Blessing, Eric Boquist, and John Leahy. The New Zealand import was conditioned by Joe Anderson and is shown here scoring one of her many wins at Sportsman's Park with her trainer at the lines. (Author's collection.)

By 1994, the "Eye in the Sky" photo-finish camera had become ultra-sophisticated, capable of distinguishing between all finishers with excruciating accuracy. This photograph shows Del Chupp and Trash (4) winning by a neck over Squatty (1) and driver Del Insko, while Honky Tonk Star (2) finishes third for driver Brian Carpenter in the 11th race on June 28, 1994, at Sportsman's Park. (Author's collection.)

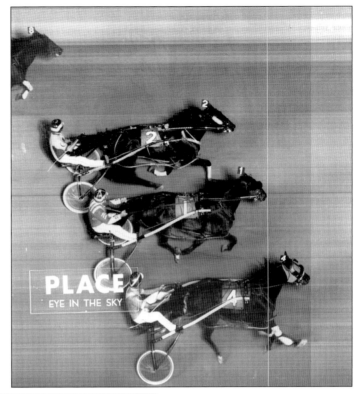

Illinois governor Jim Edgar was a solid supporter of racing in the Prairie State and could often be found in the grandstand and the winner's circle at both Thoroughbred and Standardbred venues. Here Edgar makes a trophy presentation with Josephine Abercrombie—a member of the Jockey Club and prominent in the upper crust of American Thoroughbred racing—on Illinois Derby Day, May 13, 1995, at Sportsman's Park. (Courtesy of Joan Colby.)

Conditioner Gene Cilio (left) and jockey Mark Guidry (right) accept their leading trainer and rider awards for the Sportsman's Park meeting, on June 22, 1995, from Illinois Racing Board state steward Eddie Arroyo. Guidry scored nine riding titles at Sportsman's Park, two at Arlington Park, and seven at Hawthorne. Arroyo, a former Chicago-based jockey in the 1960s and 1970s, is now a Chicago Thoroughbred racing steward. (Author's collection.)

Gary Stevens steers Glitter Woman to victory in the $300,000 Sixty Sails Handicap on May 3, 1998, at Sportsman's Park in the 22nd running of the event. Trained by Shug McGaughey, Glitter Woman won as the 8-5 favorite against six rivals. The Sixty Sails is a one-and-one-eighths-mile test for fillies and mares, ages three and older. Glitter Woman, a Florida-bred four year old at the time, romped to a four-and-three-quarters-length win and earned $180,000 for her effort. It was only the second time that Stevens had ever ridden at Sportsman's Park. (Courtesy of Sportsman's Park.)

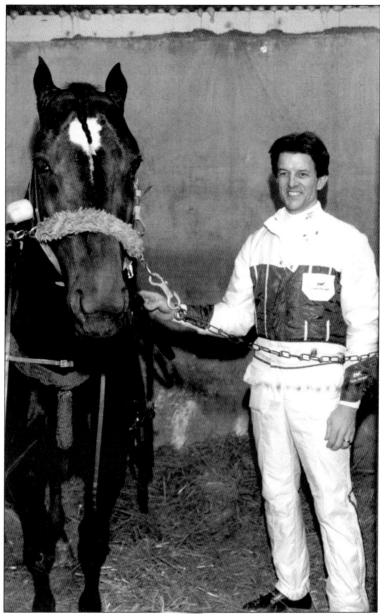

Driver Tony Morgan began scoring $4 million winning seasons in 1995 and has not slowed down since. Arriving on the Chicago scene in the mid-1980s, Morgan hailed from a Troy, Ohio, harness racing family and quickly rose to national prominence with over 12,700 winners and $94.5 million in career purses to his credit. Morgan has captured driving titles at every Chicago raceway and was named Harness Tracks of America's Driver of the Year in 1996, 1997, 2002, and 2006. The Buckeye native now resides in Warwick, Maryland, after having left the Windy City in November 2005 to race at East Coast racetracks. In 2006, Morgan had his best year ever in the win category, with 1,004—the most ever by a driver in a single season, until it was bested by his friend and protégé Tim Tetrick the following year. In 2007 and 2008, Morgan scored two of his best seasons in terms of money earnings, steering the winners of over $10.4 million each year. (Author's collection.)

In this photograph, two Chicago racing icons, announcer Phil Georgeff and jockey Eddie Arcaro, celebrate their respective accomplishments at Hawthorne on November 10, 1996. Georgeff announced over 96,000 races in his illustrious career, while Arcaro won five Kentucky Derbys, tying him with Bill Hartack as the most ever. Inducted into the National Museum of Racing and Hall of Fame in 1958, Arcaro won 4,779 races and $30,039,543 in earnings. (Courtesy of Hawthorne Race Course.)

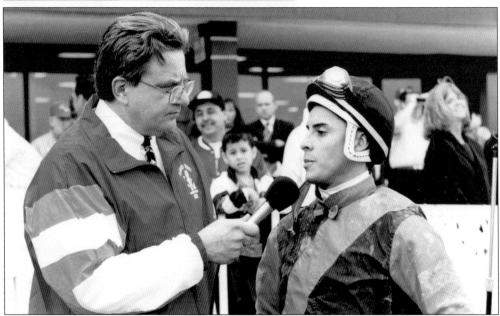

Sportsman's Park publicity director John Brokopp interviews Herberto Castillo Jr. after the jockey captured the Illinois Derby on April 8, 1999, with the Bill Mott–trained Vision and Verse. The Illinois Derby is Chicago's richest race restricted to three-year-old Thoroughbreds, a Grade II event worth $500,000 that is considered a prep for the Kentucky Derby, and it is typically run one month prior to the Run for the Roses. (Courtesy of Hawthorne Race Course.)

Seven

THE NEW CENTURY
2000 AND BEYOND

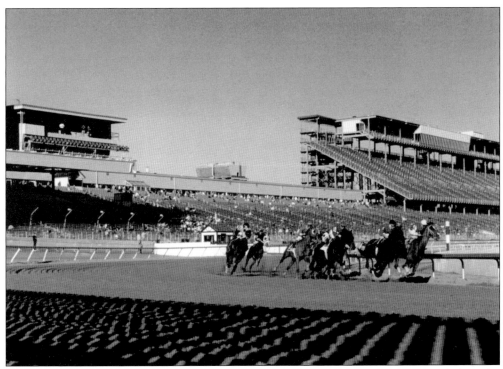

The new century brought more changes to Chicago's horse racing community, including the transformation of Sportsman's Park into a combination Thoroughbred and automobile racing venue. In 2003, financial woes forced the Cicero oval to close and it was sold to the town of Cicero for $1.8 million. In this 2000 photograph, Thoroughbreds sprint through the first turn of the revamped oval. (Courtesy of Sportsman's Park.)

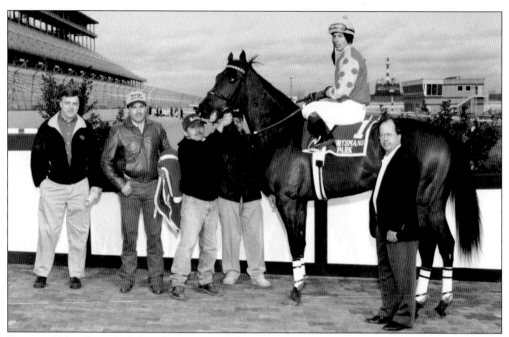

Trainer Mike Campbell has been one of the most successful and consistent Thoroughbred conditioners on the Chicago circuit for three decades. Here (right) he poses with Cicero Handicap winner Beauty Brush in the Sportsman's Park winner's circle on March 11, 2000, while his son Joel Campbell sits astride the victor. Campbell's twin sons, Jesse and Joel, are both successful jockeys. (Courtesy of Hawthorne Race Course.)

Former New York Yankees first baseman Bill "Moose" Skowrun poses with National Museum of Racing and Hall of Fame jockey Laffit Pincay Jr. at Hawthorne in 2000. Skowrun, who played in seven World Series with the Yankees, operated a restaurant across from Hawthorne, on the corner of Thirty-fifth Street and Laramie Avenue. Skowrun was a frequent visitor to Hawthorne and Sportsman's Park during the harness and Thoroughbred meetings. (Courtesy of Hawthorne Race Course.)

One of Chicago's all-time leading jockeys, Ray Sibille began riding in the Windy City in 1973, earning titles at Sportsman's, Hawthorne, and Arlington. His 4,000th career victory came on April 18, 2000, at Sportsman's Park. Sibille retired in July 2004 after posting 4,264 winners in 35 years of race riding and was awarded the George Woolf Memorial Jockey Award in 2005. (Courtesy of Hawthorne Race Course.)

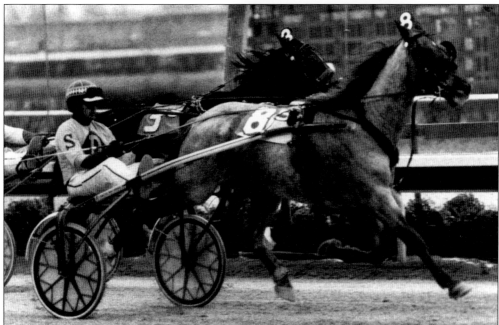

Red Rhone, winning at Hawthorne with driver-trainer Sam DeMull on February 3, 1990, earned $291,299 from 32 career wins. What made Red Rhone so striking was his unusual color, a rare red roan with black polka-dot spots covering his gray coat. He raced against the best trotters of his time—Mack Lobell and Peace Corps—and beat them both. (Author's collection.)

Richard Duchossois (right), Arlington Park chief executive officer, chats with Laffit Pincay Jr. at Hawthorne in 2000. Duchossois was always very public about his disdain for the lack of help on the part of the Illinois legislature for Illinois horse racing and shut down his facility for two years, in 1998 and 1999, before reopening in 2000. (Courtesy of Hawthorne Race Course.)

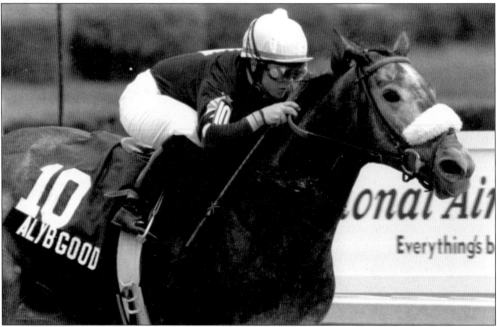

Zoe Cadman rides Alybgood to win the Indiana Maid Stakes on May 27, 2001, at Hawthorne. Cadman began riding at Arlington Park, winning with her first mount Prize and Joy on June 10, 2000, and is the all-time leading female rider there. She was the first female jockey in Chicago history to win a riding title when she did so at Hawthorne's 2001 spring meeting, with 26 winners. (Courtesy of Hawthorne Race Course.)

Driving champion Tony Morgan (left) and former baseball star Milt Pappas stand beside the pacer Ponytail Kim at Balmoral Park on September 25, 2004. Pappas, a 17-year veteran of professional baseball, participated in a sports celebrity race for charity. Pappas had pitched for the Baltimore Orioles, Cincinnati Reds, Atlanta Braves, and Chicago Cubs. Balmoral sponsors a number of charity and celebrity events annually. (Courtesy of Balmoral Park.)

Jockey Chris Emigh steered home four winners on April 30, 2005, on Illinois Champions Day at Hawthorne. Emigh hit the board in all six of his Illinois stakes rides that afternoon and finished that spring meeting with a record-setting 73 wins from only 54 riding days. The multitalented Emigh proves he is also pretty handy playing the trumpet. (Courtesy of Hawthorne Race Course.)

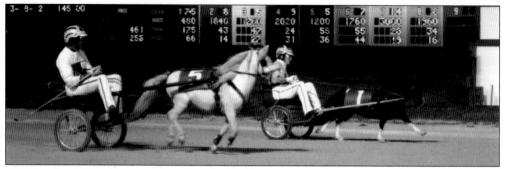

Maywood Park continues to be one of the most fan-friendly and innovative tracks in the Midwest, staging events such as "human harness races" and miniature horse races. Here two of Chicago's top reinsmen steer a pair of miniature horses to a nail-biting finish at Maywood Park in 2005. North America's top driver Tony Morgan drives Silver Shadow (5), while Tim Tetrick is behind Little Bit (1). (Author's collection.)

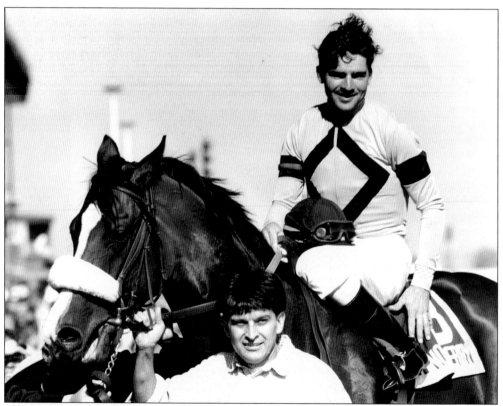

Kent Desormeaux, who captured the 2005 Illinois Derby aboard Greeley's Galaxy, repeated in 2006 as he rode favorite Sweetnorthernsait to victory at Hawthorne. This same horse would later finish second in the 2006 Preakness. Inducted into Thoroughbred racing's hall of fame in 2004, Desormeaux, a winner of over 5,000 races in his career, won his third Kentucky Derby in 2008 with Big Brown. (Author's collection.)

Jockey Robby Albarado gives Jambalaya a well-deserved pat after the pair won the 2007 Arlington Million. Jambalaya—a winner of $1,588,214 lifetime—became the first Canadian-bred horse to win the Arlington Million, and his trainer, Catherine Day Phillips, became the first female trainer to win the classic race. The son of Langfurh—Muskrat Suzie— Vice Regent won the Arlington Million at age five, besting the 2006 victor, the Tin Man. (Courtesy of Arlington Park.)

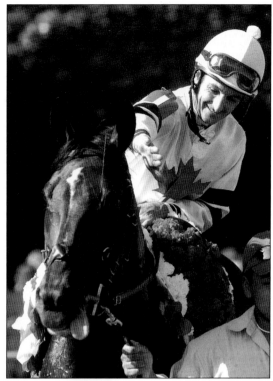

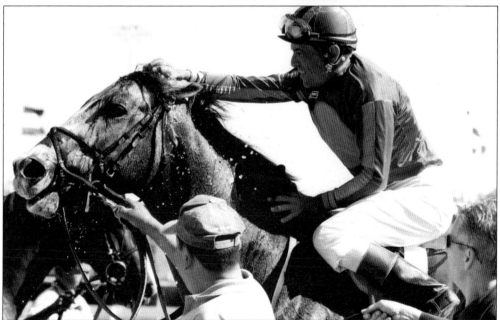

Jockey Randy Meier has been a leading member of the Chicago circuit jockey colony for three decades and is the all-time leading rider at Sportsman's Park and Hawthorne and is in the top 10 of Arlington's all-time leading jockeys. A native of North Bend, Nebraska, Meier has earned over $57.4 million in his career. He nabbed his 4,000th career victory at Arlington Park on September 16, 2007. (Author's collection.)

Illinoisan Tim Tetrick blossomed into Chicago's top driver, scoring 563 victories and $4.1 million in earnings in 2005. The Geff native began driving professionally in 2000, and by 2007, at age 26, had won more races (1,189) in a single season than any other driver in history, surpassing his mentor Tony Morgan. In 2008, Tetrick won more money ($19.8 million) in a single season than any other driver in history. (Author's collection.)

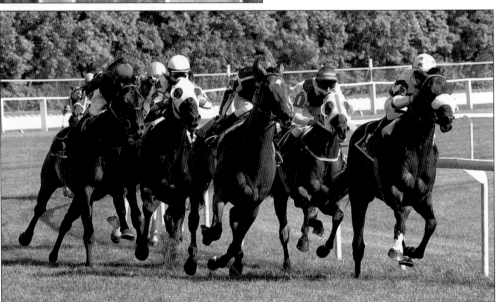

The 2008 Arlington Million winner Spirit One (right, white shadow roll) leads the field through the final turn at Arlington on his way to winning the 2008 Arlington Million with jockey Ioritz Mendizabal aboard. Arlington Park had a 2006 meeting marred by well-publicized breakdowns among the horse population and in 2007 installed the Polytrack, an artificial surface designed to give horses a safer footing. (Courtesy of Arlington Park.)

AFTERWORD

In 2009, horse racing in the Windy City continues to face a variety of foes threatening to extinguish its once bright light. While purses have remained stagnate or been lowered, ever-rising costs for feed, fuel, veterinary services, equipment, and stabling have put a severe strain on Chicago horsemen, forcing some to move their operations to other states and others to abandon the sport altogether. Increased competition for the gambling dollar from Illinois's riverboats, off-shore wagering, and slot-enhanced "racinos" in nearby states have all made racing in the Prairie State a struggle.

The sister tracks of Maywood and Balmoral offer Standardbred racing five days per week on a split schedule throughout the year, while Sportsman's Park, once the mecca of Illinois harness racing, had its 68 acres in Cicero leveled and renovated into retail space in 2009.

As the fifth-oldest racetrack in the United States, Hawthorne works diligently to feature a strong spring and fall Thoroughbred meeting at its 118-year-old facility. Sadly, the Illinois Racing Board denied giving Hawthorne harness racing dates for the 2009 season, and it seems unlikely the Stickney oval will host Standardbred racing there in the future.

Arlington Park continues to defy the odds in Illinois by supporting a world-class Thoroughbred meeting at its northwestern location during the summer months, highlighted by its annual signature event, the Arlington Million. In 2009, Arlington was awarded an extra week of racing by the Illinois Racing Board after it announced it was bidding to host the 2010 Breeders' Cup events.

In the 21st century, many Prairie State horsemen see video lottery terminal (slots) at Illinois racetracks as the way of the future, following in the footsteps of other racing jurisdictions, such as Ontario, Delaware, Pennsylvania, and Indiana, whose purses have increased dramatically with the inclusion of these one-armed bandits.

ACROSS AMERICA, PEOPLE ARE DISCOVERING SOMETHING WONDERFUL. *THEIR HERITAGE.*

Arcadia Publishing is the leading local history publisher in the United States. With more than 3,000 titles in print and hundreds of new titles released every year, Arcadia has extensive specialized experience chronicling the history of communities and celebrating America's hidden stories, bringing to life the people, places, and events from the past. To discover the history of other communities across the nation, please visit:

www.arcadiapublishing.com

Customized search tools allow you to find regional history books about the town where you grew up, the cities where your friends and family live, the town where your parents met, or even that retirement spot you've been dreaming about.